IMAGES
of America

THE MAGNIFICENT MILE
LIGHTS FESTIVAL

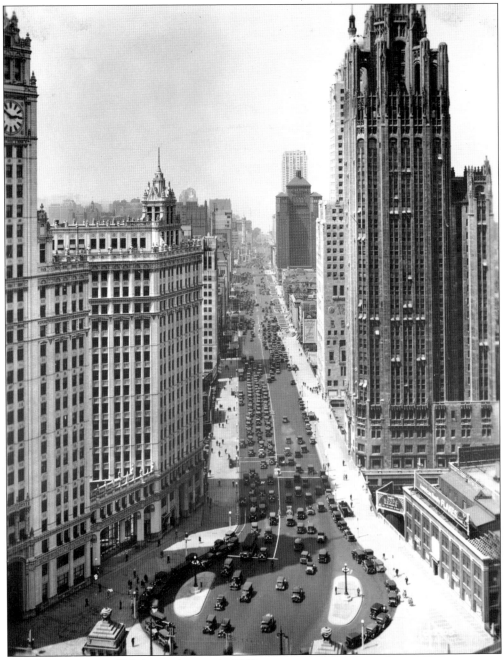

Seen here is a view of Michigan Avenue in 1933.

On the cover: The Magnificent Mile's historic Water Tower glitters with tiny white lights during the holiday season. (Courtesy of Davis Harrison Dion.)

IMAGES
of America

THE MAGNIFICENT MILE
LIGHTS FESTIVAL

Ellen S. Farrar

ARCADIA
PUBLISHING

Published by Arcadia Publishing
Charleston SC, Chicago IL, Portsmouth NH, San Francisco CA

Printed in the United States of America

Library of Congress Catalog Card Number: 2008927342

For all general information contact Arcadia Publishing at:
Telephone 843-853-2070
Fax 843-853-0044
E-mail sales@arcadiapublishing.com
For customer service and orders:
Toll-Free 1-888-313-2665

Visit us on the Internet at www.arcadiapublishing.com

*To Jack and Brad, both luminous, and the extraordinary
volunteers of The Magnificent Mile Lights Festival.*

CONTENTS

ACKNOWLEDGMENTS

True to the philosophy of The Greater North Michigan Avenue Association, this written history is the result of a contribution of many people.

I would first like to thank Marc Schulman, founding chairman of The Magnificent Mile Lights Festival®, and other stewards who guided the festival and my personal development, including Grant DePorter, Kelly Wisecarver, John Chikow, John Curran, Nicole Jachimiak, Jennifer Woolford, Eric Kromelow, Bob Dion, and so many more. I also desire to thank incredible friends from Harris, Southwest Airlines, Walt Disney World Resorts, and our media partners. Your involvement in our annual holiday event has transformed the experience we provide for our guests.

I am grateful to the many members of the association who willingly shared stories and personal histories. I also wish to thank the talented proofreader of this publication, my friend Cheryl McPhilimy, who went beyond the call of teacher and cheerleader. Also, numerous hours of image scanning were shared by perpetually smiling interns Laura O'Neill and Jessica Beukema. Many thanks to the staff of The Greater North Michigan Avenue Association for words of encouragement and chocolate shakes, with a special mention for Kelsi Johnson and Eric Stein, who were always willing to lend a helping hand.

Several photographers have documented the evolution of The Magnificent Mile Lights Festival®, including the wonderful Stanley Wlodkowski and the *Chicago Tribune*'s team, especially Glenn Kaupert. The *Chicago Tribune*, a wonderful media partner of The Magnificent Mile Lights Festival® for many years, was an incredibly rich resource on the history of Magnificent Mile holiday traditions.

Finally, thank you to Brad and Jack Farrar for your love and encouragement not just for this endeavor but in everything.

INTRODUCTION

Holiday time on North Michigan Avenue is pure magic. There is perhaps no urban wintertime image more iconic than that of Chicago's Magnificent Mile aglow with one million tiny white tree lights.

The richness of this district, a region centered on one of the most famous streets in the world, extends to its architecture, its history, its humanity, and its celebrations. A world-class street—well conceived, well built, and well cared for—North Michigan Avenue is particularly spectacular when dressed in its holiday finery and enjoyed by record numbers of visitors and area residents.

The story of The Magnificent Mile and its holiday traditions hearken to convictions of Chicago's great city planner and famed architect Daniel H. Burnham. In his 1909 vision for the Plan of Chicago, Burnham wrote: "Make no little plans; they have no magic to stir men's blood and probably themselves will not be realized. Make big plans; aim high in hope and work, remembering that a noble and logical diagram once recorded will never die, but long after we are gone will be a living thing, asserting itself with growing intensity. Remember that our sons and grandsons are going to do things that would stagger us. Let your watchword be 'order' and your beacon 'beauty.'"

In the coming decades, a line of like-minded Chicagoans—business people, developers, politicians, and volunteers—stayed fast to Burnham's ideals. By the mid-20th century, North Michigan Avenue was a bustling and attractive street with worldwide recognition. Not surprisingly, the street became a focal point of holiday decorating. Merchants and property owners got involved, and the street offered such visual treats as the Lindbergh Beacon, the outlined star and tree shapes in the windows of the Palmolive building, and the Water Tower star. It was on Michigan Avenue that the tradition of white tree lights originated. In a fortunate experiment, the visual display director of Saks Fifth Avenue tried wrapping the trees in tiny white lights, a practice that caught on and now signifies the spirit of the holidays around the world from suburban front yards to municipal parks to the Champs Elysees in Paris. Celebrities flocked to North Michigan Avenue for the honor of being the one to "flip the switch," thereby turning on the lights and kicking off the holiday season.

In the 1990s, the avenue inspired an even grander vision for holiday celebration. No longer a simple flip of the switch, the turning on of the lights was staged as a block-by-block procession in 1992. The concept caught on and within just three years, it drew some 250,000 spectators. The event continues to grow and become more elaborate each year. Today The Magnificent Mile Lights Festival includes a full day's worth of shows and events and culminates in the national

television broadcast of some one million participants experiencing the ritual lighting and final fireworks celebration. The festival draws celebrities and major sponsors, including Walt Disney World Resorts, which provides a hearty amount of talent, production expertise, and visuals to the event festivities. Since 1994, the master of ceremonies, delighting children and encouraging the crowds to wish and dream, has been Mickey Mouse.

The success of The Magnificent Mile Lights Festival, much like the success of the avenue itself, is largely due to a committed group known as The Greater North Michigan Avenue Association. It is a dedicated band of leaders and volunteers who have recognized and cherished the greatness of the street. Made up of retailers, hotels, restaurants, other businesses, and medical and cultural institutions, the members of The Greater North Michigan Avenue Association enhance The Magnificent Mile streetscape and put on the festival each year strictly through private funds and thousands of volunteer hours.

Their efforts pay off. The charms and celebrations of The Magnificent Mile during the merriest season of the year are irresistible. This book is designed to share the history of the holiday celebrations and to jog the memory of the reader who might have witnessed the star illuminated on Christmas Eve on the Palmolive building in the 1950s or who brought a delighted child to see Mickey Mouse light the tiny white lights at The Magnificent Mile Lights Festival. As the *Chicago Tribune* has reported, "Rarely do the twin attractions of magic and majesty blend as successfully as they do each holiday season along North Michigan Avenue's Magnificent Mile."

One

ONE OF THE GREAT
AVENUES OF THE WORLD

North Michigan Avenue glitters during the holiday season, when one million tiny white lights cover its towering trees. This world-famous avenue has long stood witness to and has inspired the festive holiday practices of the street. It owes much of its character to the construction of the Water Tower and the extension of Michigan Avenue north of the Chicago River via the Michigan Avenue Bridge.

A well-recognized landmark, the historic Water Tower withstood the great Chicago Fire of 1871 and is an iconic symbol of Chicago's resilience and spirit. It is the oldest structure along North Michigan Avenue. The Michigan Avenue Bridge, constructed in 1920, connected Pine Street to the section of Michigan Avenue south of the Chicago River. Following the heralded opening of the bridge, North Michigan Avenue flourished. According to a December 5, 1937, article in the *Chicago Tribune* and accompanying map titled, "What a Bridge Can Do," 33 buildings were constructed from 1920 to 1937 on North Michigan Avenue.

The North Central Association, an organization of area property owners, managed this remarkable development. One of the association's main objectives was to see that no buildings were erected that would jeopardize the street's future opportunity to become an avenue of luxury. It was already the residential home to notable Chicagoans, including businessmen William B. Ogden, Chicago's first mayor; Walter L. Newberry, founder of Chicago's famed Newberry Library; and Joseph Medill, publisher of the *Chicago Tribune*.

Over the decades, the street changed from residential to vibrantly urban. Upon prompting from innovative developer and realtor Arthur Rubloff, the North Central Association became The Greater North Michigan Avenue Association in 1947. The area served by this volunteer-driven consortium represented a "magnificent square mile," stretching from Lake Michigan to the Chicago River and from Randolph Street to North Avenue. Rubloff coined the term "The Magnificent Mile" to define this stretch of Michigan Avenue.

Today The Magnificent Mile community is a planned mix of commercial and residential properties, hotels, retail and restaurant establishments, museums, and education and medical institutions. The Greater North Michigan Avenue Association maintains the public way, manages its growth, and plans its celebrations.

The Magnificent Mile has inspired a host of holiday traditions and decoration. The facades and attractions that draw millions of visitors each year stand as grand witness and glamorous backdrop for the evolution of the area's holiday festivities.

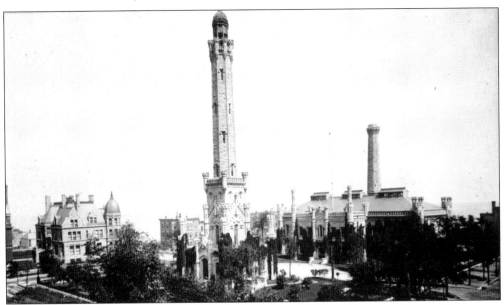

The longest-standing structure on Michigan Avenue, the Water Tower is the steadfast crown jewel of the street. Desiring "a structure with more than usual architectural beauty," the board of public works engaged one of the city's best-known architects, William W. Boyington, to design the tower as part of a water system overhaul. To house the waterworks and its standpipe tower, Boyington chose a style called castellated Gothic. A first of many grand parades along North Michigan Avenue celebrated the laying of the Water Tower cornerstone on March 25, 1867, with Mayor John B. Rice in attendance. Today, 141 years later, a tablet commemorating these events can be found on the northeast corner of the tower. A rare survivor of the great Chicago Fire of 1871, the Water Tower was described as "thoroughly fire-proof, being constructed wholly of stone, brick and iron," by DeWitt C. Cregier, engineer of the Pumping Works in 1869. (Courtesy of the Chicago History Museum.)

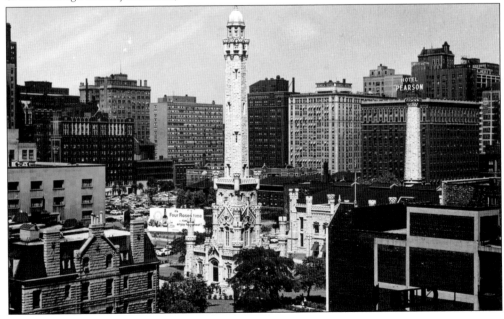

The Water Tower stands as Chicago's most familiar, historic, and cherished landmark. Shown here in 1890 (above, opposite page), the 1950s (below, opposite page), 1972 (right), and 2006 (below), this elegant and mighty structure was a constant in The Magnificent Mile's rapidly changing skyline during the 20th century and remains a symbol of Chicago's "I will" spirit. (Courtesy of the Greater North Michigan Avenue Association.)

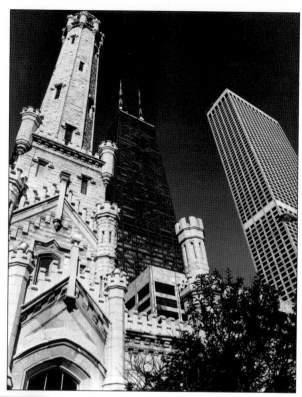

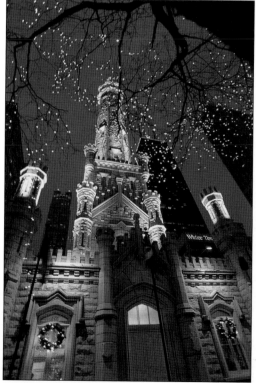

Throughout its history, the Water Tower has been the hub of holiday activity for North Michigan Avenue and its neighborhoods. Complemented by tiny white tree lights adorning the park's meticulously maintained trees, the tower shines during the holiday season, dressed in holiday wreaths and greenery. (Courtesy of Davis Harrison Dion.)

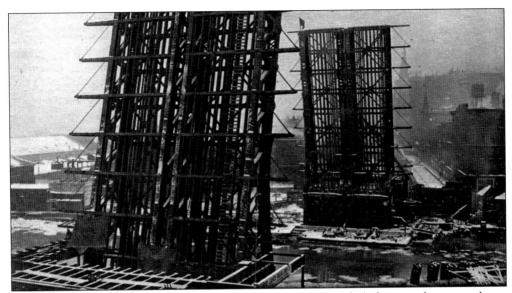

The link of South Michigan Avenue to Pine Street to the north (subsequently renamed as a continuation of Michigan Avenue) was a pioneering, double-decked steel bascule bridge built over the Chicago River. This photograph, from the *Chicago Tribune Pictorial Weekly*, was taken in 1919 after the steel framework of the bridge was completed. A collaboration of architect Edward H. Bennett and engineer Hugh Young, the construction of this bridge enabled the "extension" of Michigan Avenue that eventually became known as The Magnificent Mile and ranked as one of the great avenues of the world. (Courtesy of the Chicago Daily Tribune.)

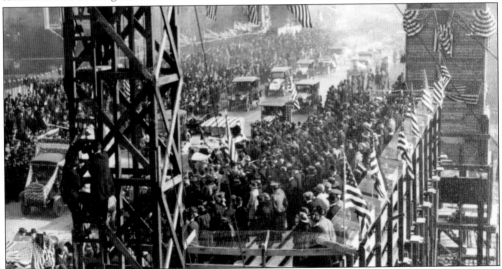

An opening celebration was planned for the Michigan Avenue Bridge on May 14, 1920. Chicago Plan Commission chairman Charles Wacker and board of local improvements president Michael Faherty stood beside Mayor William H. "Big Bill" Thompson for a ribbon cutting to open the upper level of the new Michigan Avenue Bridge. Crowds of onlookers, fireworks, boats in the river sounding their whistles, and a band playing "The Star-Spangled Banner" marked the celebration, while workers on the unfinished lower level continued construction during the ceremonies. This festive event and its unique location for a fireworks show set the scene for many celebrations for the century to come. (Courtesy of the Chicago History Museum, J. Sherwin Murphy.)

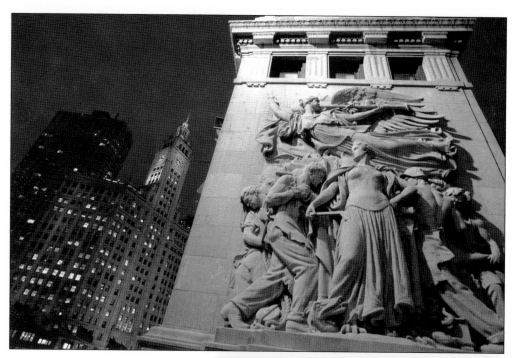

One of the most photographed bridges in Chicago, the monumental towers of the Michigan Avenue Bridge were built with Bedford stone and mansard roofs in 1928. Lined with flags, the bridge serves as a grand gateway to The Magnificent Mile and features detailed bas-relief sculptures depicting early Chicago history. It is also the location of the grand finale of the annual Magnificent Mile Lights Festival, which kicks off the holiday season for North Michigan Avenue and its neighborhoods. (Above, courtesy of the Chicago Tribune; right, courtesy of Ron Schramm.)

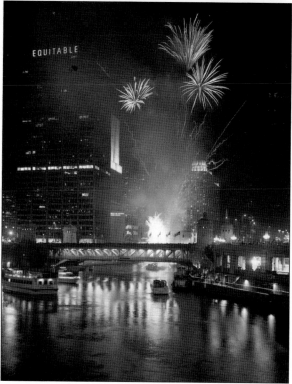

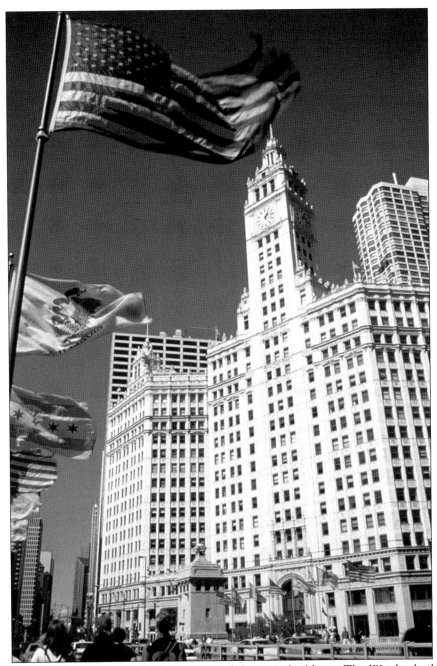

Framing the Michigan Avenue Bridge are several dramatic buildings. The Wrigley building is the earliest of the celebrated skyscraper group at the intersection of Michigan Avenue and the Chicago River. A soaring, white terra-cotta masterpiece, it was designed and built between 1921 and 1924 by the Chicago architectural firm of Graham, Anderson, Probst and White, the successor to Daniel Burnham and Company. Setting the tone for the rest of the development of North Michigan Avenue, the Wrigley building stands as a luminous Chicago icon and timepiece at the gateway of The Magnificent Mile. The Wrigley building was Chicago's tallest skyscraper until the Tribune Tower was built in 1925. (Courtesy of Kelly Wisecarver.)

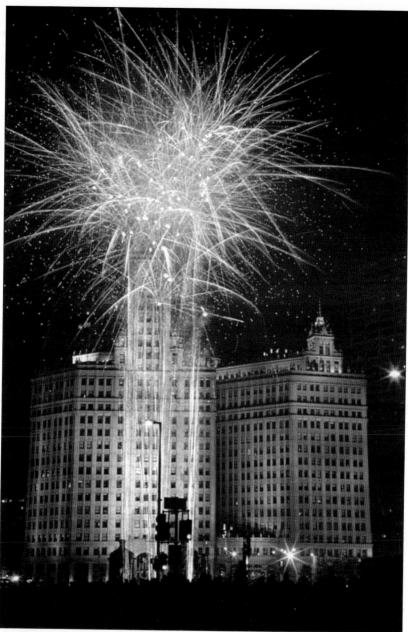

In 1958, Ernest Fuller interviewed Gilbert H. Scribner of Winston and Company, then managing agent for the Wrigley building, for an article in the *Chicago Daily Tribune*. Scribner touted the attributes of the pioneering structure, including the huge clock tower. "If you ever want to take on a major responsibility, just provide a clock for the public," said Scribner. "When it's a little slow or fast, or stopped for some reason, every helpful soul in town is on the phone to let you know. It's almost like running a ball club." The Magnificent Mile Lights Festival uses the Wrigley clock tower to launch its grand finale fireworks on time, and the inspirational facade serves as the event's backdrop. Offices for the William M. Wrigley Jr. Company, a sponsor of The Magnificent Mile Lights Festival, remain in the historic structure. (Courtesy of Stanley Wlodkowski.)

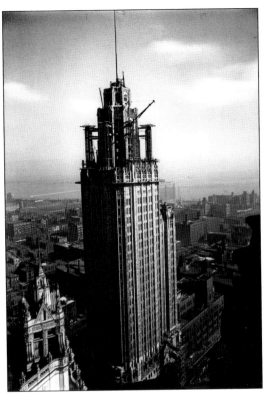

In 1922, 260 architects from around the world submitted designs for the new Tribune Company headquarters. The winning team, Raymond Hood and John Howells, proposed a 34-story neo-Gothic tower, seen here in the final stages of construction, which was completed in 1925. (Courtesy of the Chicago History Museum.)

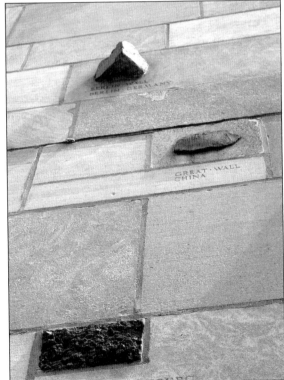

The lower-level facade of the building is embedded with more than 150 stones from landmarks around the world, including the Taj Mahal, the Berlin Wall, the pyramids, and the Great Wall of China. (Courtesy of Eric Stein.)

In "Impressions of Chicago's Christmas," appearing December 30, 1934, in the *Chicago Daily Tribune*, reporter R. C. Thompson recalled a WGN Radio concert carried via loudspeaker system to the Michigan Avenue streetscape, and wrote, "North Michigan Avenue at dusk. Tribune Tower. Crowds of office workers hurrying home from the loop. Belated shoppers with arms full of packages. South—the bridge over the river and the Wrigley building. North—the Water Tower and the Palmolive building with its cross of lights etched against the black bulk of the building proper. The traffic lights flash green, a whistle blows, and an endless stream of cars begins to move. Over all, like a benediction, the snow falls in big white flakes. And out of the night, seemingly from nowhere, like the snowflakes, voice of an invisible choir." (Courtesy of the Chicago History Museum; photgraph by Gustav Frank.)

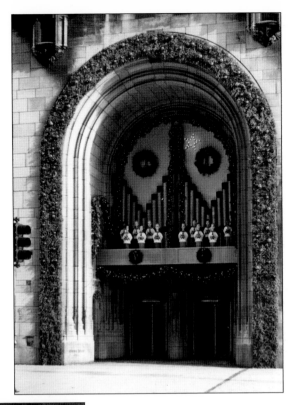

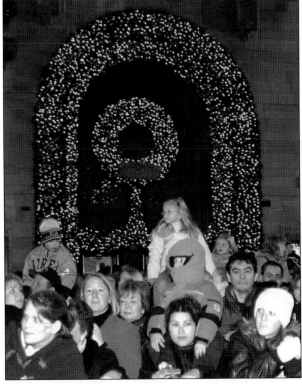

The Tribune Tower's richly carved entrance arch is three-stories high and is pictured in its 1960s holiday finery with choirboys (above) and again in 2004 (left) during The Magnificent Mile Lights Festival. The Tribune Company was a major sponsor of The Magnificent Mile Lights Festival for 12 years, providing significant media exposure, content, and corporate support for the event. (Courtesy of the Chicago Tribune.)

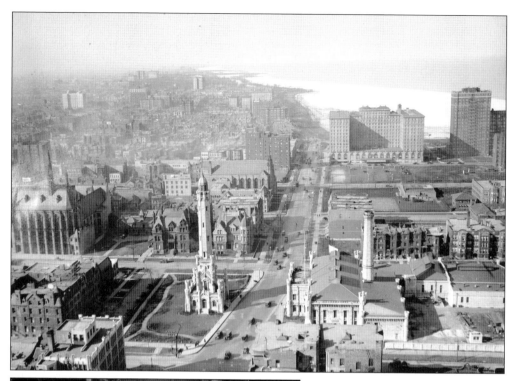

Standing strong at the north end of The Magnificent Mile, The Drake Hotel Chicago occupies one of the most beautiful locations in the city, overlooking Lake Michigan and Oak Street Beach. Designed by Marshall and Fox in 1920, the 13-story limestone structure features grand public spaces, beautiful holiday decor, and a history of famous guests. (Above, courtesy of the Chicago History Museum; left, courtesy of the Drake Hotel Chicago.)

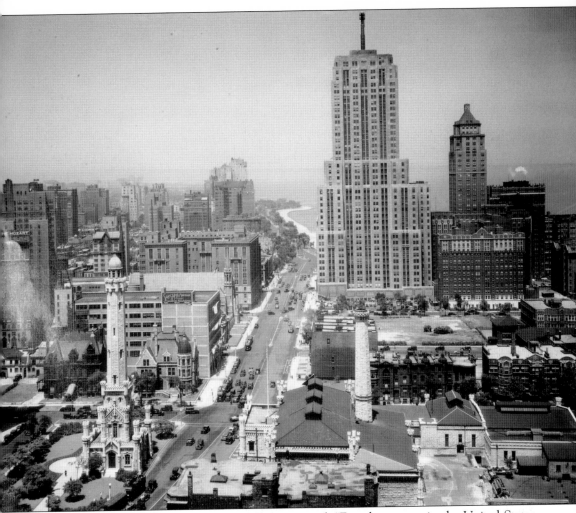

Chicago's 1999 Landmark's Designation Report stated, "Few skyscrapers in the United States better defined the optimism on the 1920's and the progressive character of architecture than the Palmolive Building. With its streamlined, monumental form, highlighted by dramatic setbacks, the Palmolive heralded a decidedly new form for the design of skyscrapers. Since its opening, the Palmolive Building has been an indelible icon on the city skyline, defining what has become one of the premier office, residential and shopping avenues in the United States. The quality of its design and craftsmanship makes the Palmolive Building a premier edifice emblematic of Chicago's Magnificent Mile." (Courtesy of the Chicago History Museum.)

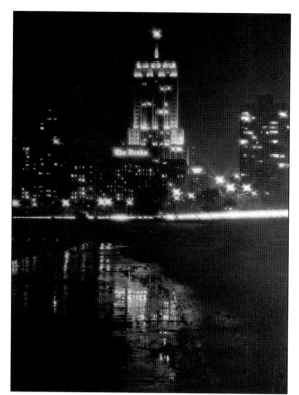

Designed in 1929 by Holabird and Root, the Palmolive building enhanced The Magnificent Mile's growing reputation as an architectural showplace. When the art deco building was first constructed, the facade served as an unobstructed and beautiful icon of North Michigan Avenue. Lighting features such as the Lindbergh Beacon and annual holiday illumination of its facade added to its glamour. In August 1930, Pres. Herbert Hoover pressed a telegraph button in the White House to light the Lindbergh Beacon, and for more than 50 years, it continued its reliable sweep of the night sky. (Courtesy of The Greater North Michigan Avenue Association; photograph by John Hendry Jr.)

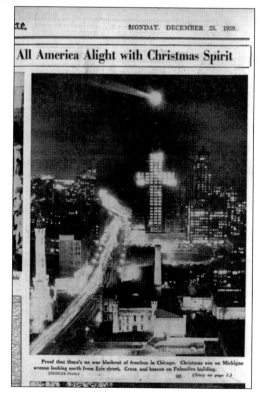

All America Alight with Christmas Spirit

MONDAY, DECEMBER 25, 1939.

Proof that there's no war blackout of freedom in Chicago. Christmas eve on Michigan avenue looking north from Erie street. Cross and beacon on Palmolive building.
[TRIBUNE Photo.]
(Story on page 1.)

An illuminated cross graced the building facade each Christmas Eve from its first holiday season until 1938. In later years, additional shapes that appeared on the face of the Palmolive included a 21-story Christmas tree and a large star. (Courtesy of the Chicago Tribune.)

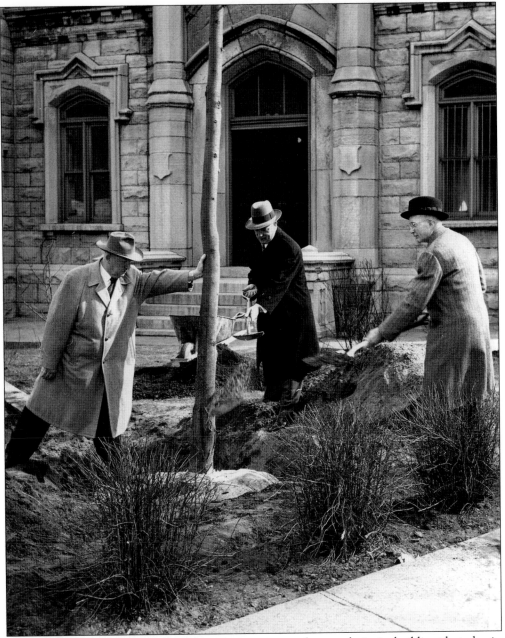

Business leaders along North Michigan Avenue invested not only in its buildings but also in its beauty. Seen here in Water Tower Park in the 1950s planting trees, which were adorned with the iconic tiny white lights each holiday season, are Arthur Farwell, Hugh Michels, and Newton Farr, past presidents of The Greater North Michigan Avenue Association. Honoring the tradition set by early leaders, Michigan Avenue business owners and managers privately fund and develop the spring, summer, and fall landscaping plans for each garden—52 in total—lining The Magnificent Mile's public way. They also string the trees with the tiny white lights from an entirely private funding base, sharing a commitment for enhancing The Magnificent Mile. (Courtesy of The Greater North Michigan Avenue Association.)

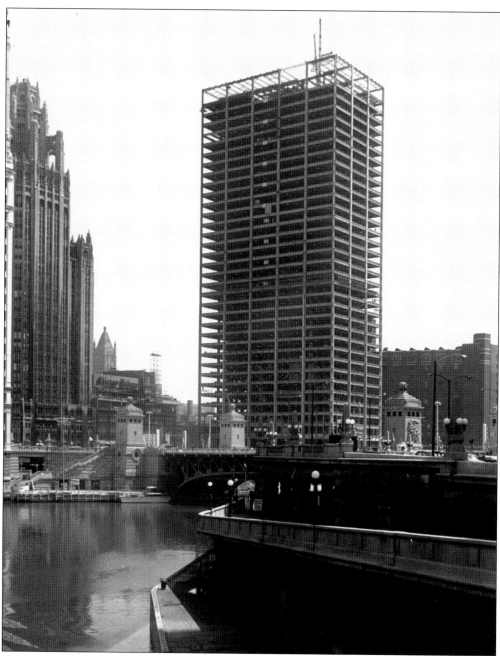

Ground was broken in June 1963 for the 35-story Equitable building, fronting the east side of Michigan Avenue at the Chicago River. Built by architects Skidmore, Owings, and Merrill, the Equitable building, now known as 401 North Michigan Avenue, is noteworthy for its large plaza built in conjunction with its neighbor, the Tribune Tower. (Courtesy of Chicago History Museum.)

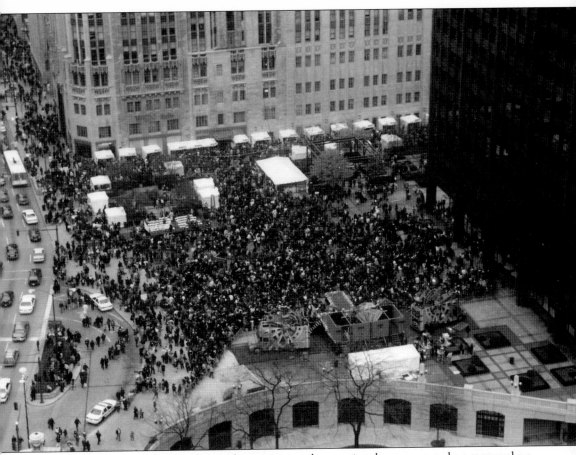

The vast plaza, a refreshing and open feature in an urban setting, has proven to be a tremendous attribute for the entire Magnificent Mile district. Due in large part to the community spirit of its owners, Zeller Realty Group, Tribune Company, and the University of Chicago–Gleacher Center, large-scale events, including The Magnificent Mile Lights Festival and weekly winter fireworks shows, are held in this plaza now called Pioneer Court. (Courtesy of the Chicago Tribune.)

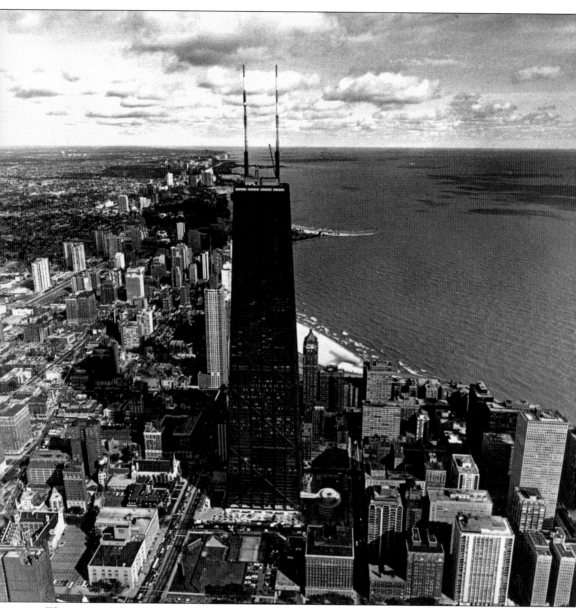

The soaring John Hancock Center, at North Michigan Avenue between Chestnut and Delaware Streets, was built in 1969 by Skidmore, Owings, and Merrill. The building's exterior is aluminum and glass with diagonal supports that highlight the strength of its design with visual interest. The building transforms itself into a larger-than-life holiday decoration, illuminating its crown with lights of red and green during the season of light. (Courtesy of The Greater North Michigan Avenue Association.)

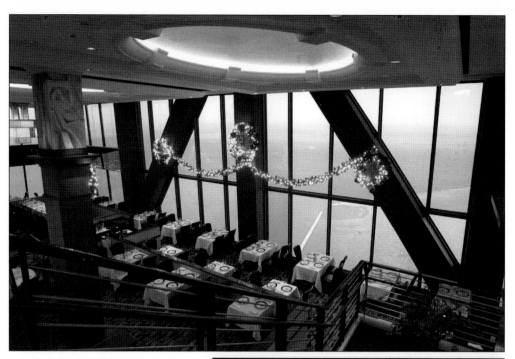

Located atop the John Hancock Center, the critically acclaimed Signature Room at the 95th offers sweeping views of the city and contemporary American fare. Seen here in its holiday finery, the art deco interior of the restaurant, with its large windows and elegant wood designs, complements the view. Just a level below on floor 94, spectacular views of up to 80 miles in all directions can also be found from the Hancock Observatory, which offers visits with Santa. And 1,127 feet below, a lit holiday tree on the building plaza beckons guests. (Above, courtesy of the Signature Room; right, courtesy of Ron Schramm.)

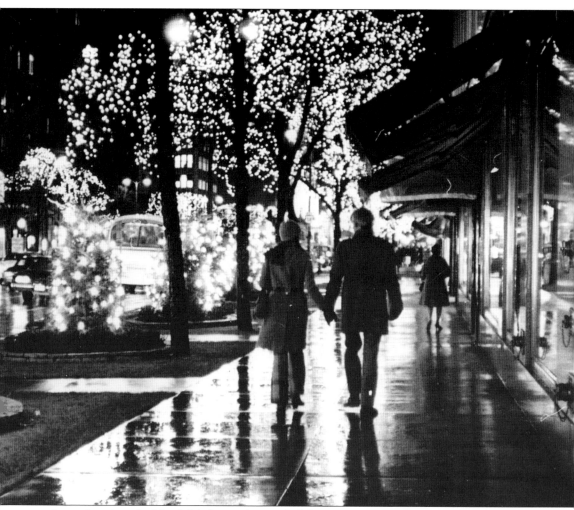

A couple enjoys the North Michigan Avenue holiday streetscape in the 1970s. (Courtesy of the Chicago Tribune.)

Two

HOLIDAYS ALONG THE MAGNIFICENT MILE

As Michigan Avenue developed in the 20th century, so did its holiday traditions. The ever-more-impressive streetscape enticed generations of Chicagoans and visitors to make a trip to this magnificent street part of their holiday celebration. The district's businesses did not disappoint. Then as now, windows beckoned shoppers inside with tantalizing merchandise and festive decor. Leisurely carriage rides provided a romantic view of Chicago's famed district. Festive trolleys traveled from one end of the avenue to another, off to other sites in the city and back to Magnificent Mile hotels. Pastry chefs created elaborate desserts and displays made of sugar, marzipan, and chocolate. Critically acclaimed restaurants served small bites and five-course meals.

In the 1950s, the avenue was awash in lights and lighting effects at the holidays. The Greater North Michigan Avenue Association began an annual installation of a large star on the facade of the historic Water Tower. Over the decade, a roster of invited actors and musicians came to the city to officially start the holiday season by "throwing the switch" to illuminate the star adorning the tower. Widely covered in newspapers and discussed by passersby, the illuminated star affixed to a beloved city icon was a powerful holiday visual for Chicagoans. In addition, the Palmolive building made a dramatic statement at the north end of the avenue with its Lindbergh Beacon and blacked-out window effects. And, inspired by the fortunate result of retailer Saks Fifth Avenue's holiday experiment, the practice of wrapping the avenue's trees in tiny white lights was adopted street wide. Quickly copied around the world, the tree lights were a uniquely Michigan Avenue invention, making their debut on The Magnificent Mile in 1959.

North Michigan Avenue was a memorable destination at any time of year but during the holiday season was all the grander.

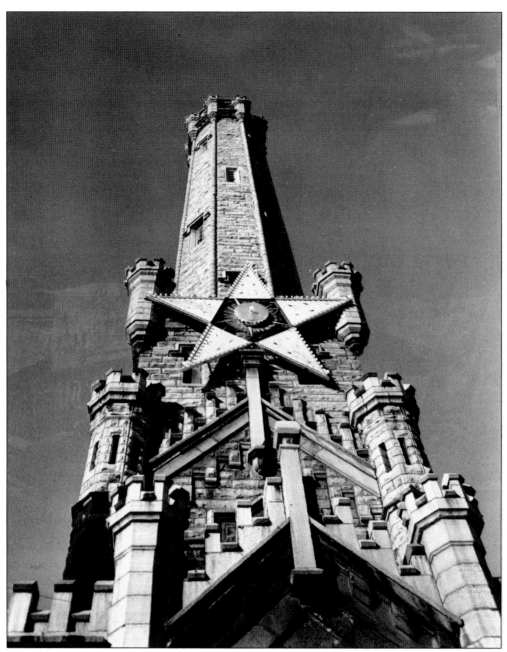

Every year, extensive holiday decor graced The Magnificent Mile. During the 1950s, a celebrity came to Water Tower Park to illuminate a symbolic star, joining local personalities and Greater North Michigan Avenue Association officials to pull the switch and officially begin the holiday season. The star was the recognized image along North Michigan Avenue prior to the introduction of the tiny white lights. (Courtesy of The Greater North Michigan Avenue Association.)

Installed by members of the Greater North Michigan Avenue Association, a 50-foot-tall Christmas tree with 1,500 lights and a six-foot star topper dressed up Water Tower Park in 1949. (Right, courtesy of The Greater North Michigan Avenue Association; below, courtesy of the Chicago Tribune.)

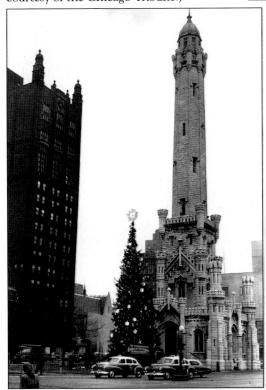

Actress Carmen Miranda was the first to ceremonially "throw the switch" to illuminate a 67-foot-tall decorated holiday tree in Water Tower Park in November 1951. Pictured from left to right with Miranda are E. R. Cook, president of The Greater North Michigan Avenue Association; L. M. Johnson, street commissioner; Nelson Forrest, executive director of the association; and W. W. DeBerard, city engineer. Billed as the largest holiday tree east of the Rocky Mountains, this balsam pine was from a preserve in Michigan's Upper Peninsula, requiring 12 men to cut it down and ship it by car and rail to Chicago. (Courtesy of The Greater North Michigan Avenue Association.)

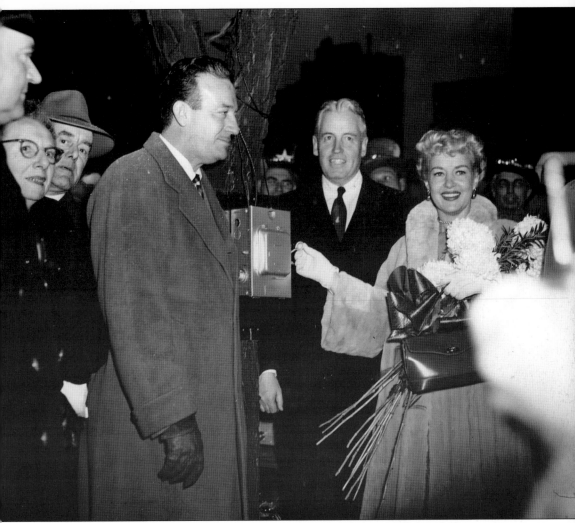

The holiday season in 1953 officially began on November 25 when Hollywood film star Betty Grable and her husband, orchestra leader Harry James, arrived in Chicago to flip a 3:00 p.m. master switch to illuminate a 35-foot star on the historic Water Tower. Grable's famous pin-up pose during World War II adorned barracks all around the world. Later, Twentieth Century Fox had her legs insured with Lloyds of London for $1 million. (Courtesy of The Greater North Michigan Avenue Association.)

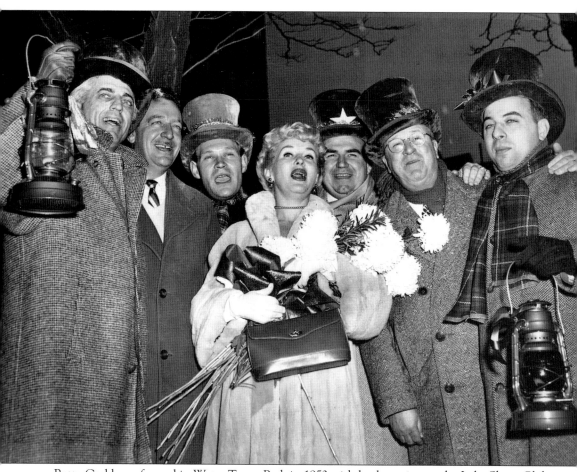

Betty Grable performed in Water Tower Park in 1953 with back-up singers the Lake Shore Club Carolers. (Courtesy of The Greater North Michigan Avenue Association.)

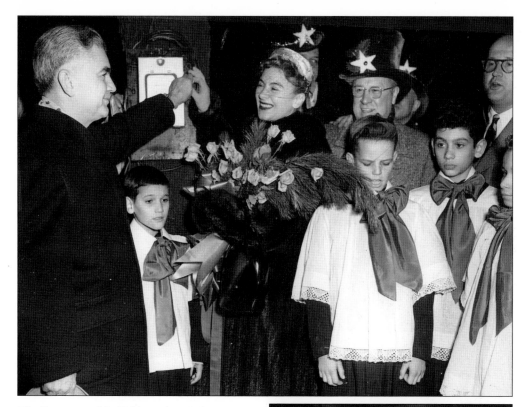

The Incomparable Hildegarde, a cabaret singer and first lady of supper clubs, was the celebrity who illuminated the Water Tower star on December 1, 1954. She was accompanied by the Lake Shore Club Carolers, who performed along North Michigan Avenue during the holiday season, and the St. Philip Benizi Church altar boys choir. Later the same day, a star, 14 stories from tip to tip, was illuminated on the Palmolive building at twilight, with the Lindbergh Beacon shining. Carl E. Olin, building engineer, was the visionary who developed the tradition of blacking out windows on the Palmolive building facade to illuminate a holiday shape on Christmas Eve. Shapes that appeared on the facade of the Palmolive building on Christmas Eve included a cross, a tree, and a star. The Palmolive lit up its facade on the day of The Greater North Michigan Avenue Association's ceremonial flip of the switch in Water Tower Park. (Above, courtesy of The Greater North Michigan Avenue Association; right, courtesy of the Chicago History Museum.)

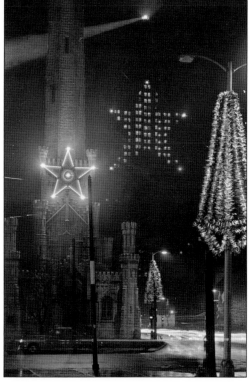

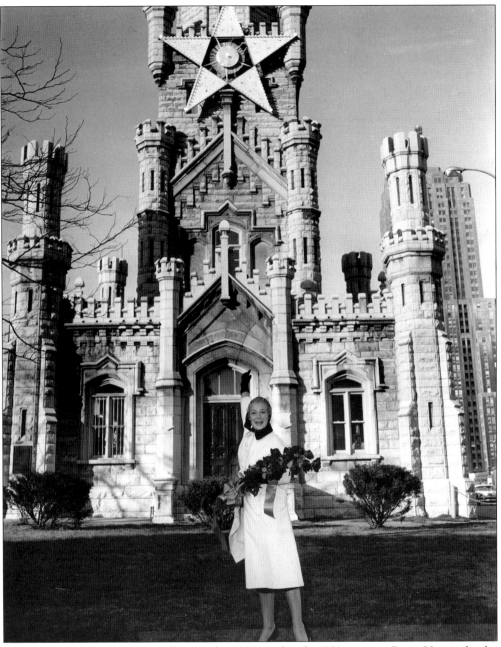

A star of musical and dramatic films in the 1940s and early 1950s, actress Betty Hutton lit the Water Tower star in 1955. (Courtesy of The Greater North Michigan Avenue Association.)

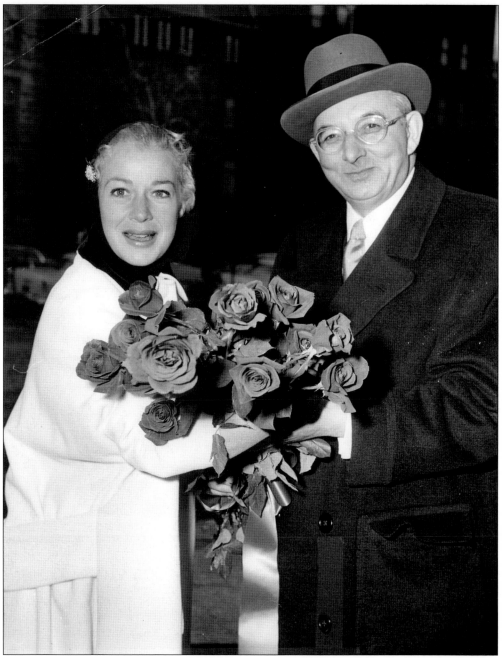

Hutton is pictured with Arthur Rubloff, founder of one of the largest real estate development firms in Chicago, who coined the term "The Magnificent Mile" to define the stretch of North Michigan Avenue from the bridge to Oak Street. Rubloff's vision for both the infrastructure and brand of North Michigan Avenue helped define The Magnificent Mile's world-class urban character. (Courtesy of The Greater North Michigan Avenue Association.)

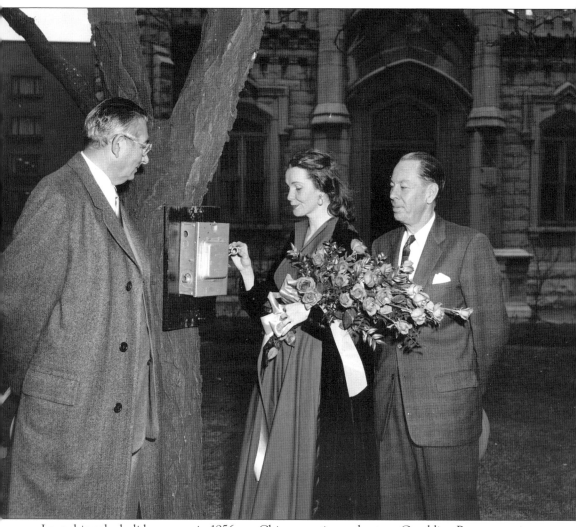

Launching the holiday season in 1956 was Chicago native and actress Geraldine Page, returning to Chicago to headline in two shows during the first season of the new Studebaker Theater. These shows were Eugene O'Neill's *Marco Millions*, which ran October 30 through November 25, and *The Immoralist*, which opened on Christmas day at the Studebaker. Later in her career, Page was recognized as "the first lady of American theater." (Courtesy of The Greater North Michigan Avenue Association.)

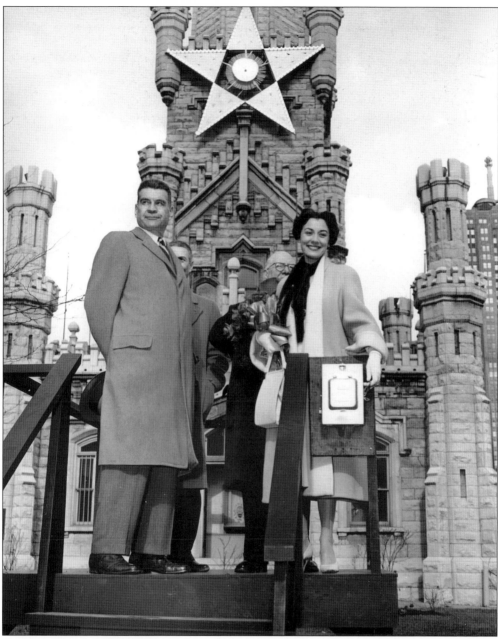

On November 5, 1957, *My Fair Lady* opened at the Schubert Theater in Chicago and ran for a year after traveling from New York to other American cities. Anne Rogers, a British actress who portrayed Eliza Doolittle, was on hand with Otis L. Hubbard, future chairman of The Greater North Michigan Avenue Association, to illuminate Water Tower Park in 1957. (Courtesy of The Greater North Michigan Avenue Association.)

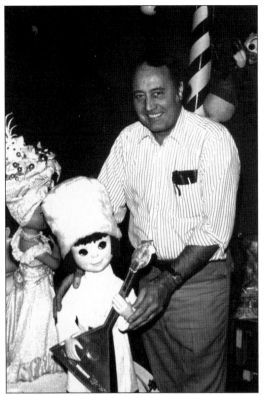

Reminiscing with Michael Hirsley, a *Chicago Tribune* correspondent, Joe Kries, the visual display director for Saks Fifth Avenue on North Michigan Avenue, recalled standing alongside George Silvestri from Silvestri Art Manufacturing Corporation in 1959 to see if an idea they conceived would work. "Kries had sold the shop's traditional Christmas decoration—an ornate metal design that was attached to the storefront to form the outline of a Christmas tree . . . In its place, he, Silvestri and Bob Vondron [pictured here at left], partner at Silvestri, took a chance on a theretofore untried Christmas decoration: They strung tiny, white lights—imported from Italy and smaller than any ever before seen by Chicagoans—outlining every branch in the half dozen barren elm trees in front of the store." "As soon as we flipped the switch, we knew we'd done the right thing," Kreis remembered. "It looked fantastic. Even while I was standing there, passersby were already talking about how pretty it looked." (Left, courtesy of Marian Jarocki; below, courtesy of The Greater North Michigan Avenue Association.)

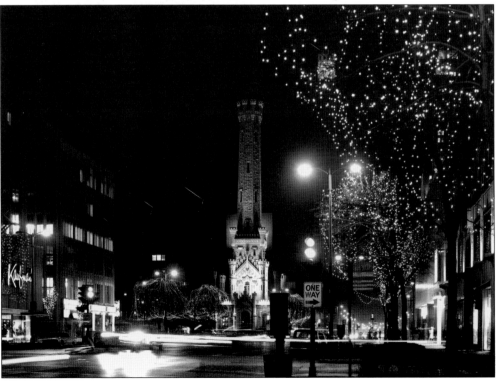

Former Saks Fifth Avenue manager Harold J. Clyne was among the spectators at the inaugural lighting of the tiny white lights. "When they went on, it was a startling thing. Pedestrians stopped to look, and cars slowed down," Clyne said. "I thought then, and I still think, 'What a stroke of good fortune,' first for Saks, then for the whole avenue. From those humble beginnings—a visual experiment—a Christmas tradition along The Magnificent Mile was born—within a year, other North Michigan Avenue merchants joined Saks in lighting the trees in front of their stores. (Courtesy of the Chicago History Museum and Ron Schramm.)

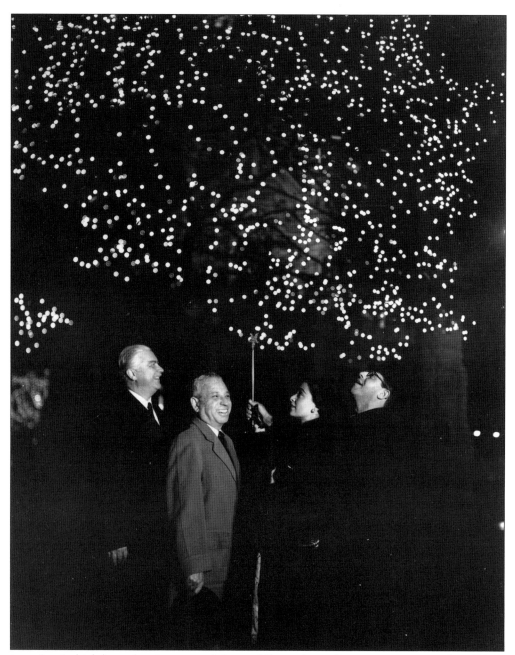

Jerry Lewis (right), at the time one of the world's top box-office earners, appeared in Water Tower Park for the official flip of the switch to light North Michigan Avenue's tiny white lights on November 22, 1960. He was in Chicago with Anna Maria Alberghetti to promote *CinderFella*, Lewis's answer to the classic Cinderella story playing at the Woods Theater. Also pictured are Hugh C. Michels (left) and B. E. Arnold (second from left), president and vice president, respectively, of The Greater North Michigan Avenue Association. (Courtesy of The Greater North Michigan Avenue Association.)

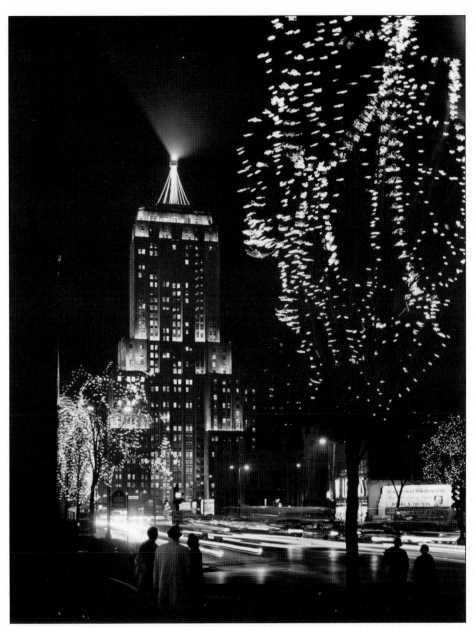

In 1961, the Lindbergh Beacon atop the Palmolive building was transformed into a holiday tree. This tree's base was 39 stories off the ground, and its trunk the Lindbergh Beacon standard. Fashioned wholly of lights—950 total—the illuminated star on the top of the tree was the shining beacon itself. Mary Merryfield of the *Chicago Daily Tribune* wondered what it was like "atop a star" and interviewed George Greenwood, the person in charge of changing two carbon light sticks every two hours, ensuring that the beacon continued its luminous 30-second-long revolutions. To do this, Greenwood, or one of his two beacon-keeper relief men, left his post on the 39th floor of the Palmolive building for a seven-and-a-half-story tiny elevator and a 24 rung, narrow ladder that led to the light. Greenwood told Merryfield that the view from the very top of the tree is the best part of his job, "I never get tired of it." (Courtesy of the Chicago History Museum.)

lights on
. . . everybody

You can see the wonders of the world . . . shop in exotic foreign cities—or come to the North Michigan Avenue Area this holiday season. We're a combination of both. Our lights are as famous as the Fjords of Norway — our Christmas gifts the pick of the crop from all over the world. Try us—you'll find it an exhilarating and enjoyable experience.

GREATER NORTH MICHIGAN AVENUE ASSOCIATION

The Magnificent Mile with tiny white lights strung in its trees became an annual event to the delight of Chicago's residents and visitors. As the tree lights became the branded decor of North Michigan Avenue, many visitors, Chicagoans, and business leaders were quoted in the *Chicago Daily Tribune*, praising the effect of the lights and the efforts of the business owners funding the fixtures. In the mid-1960s, the average cost per tree to string the lights ranged from $280 to $420, depending on its size. (Courtesy of The Greater North Michigan Avenue Association.)

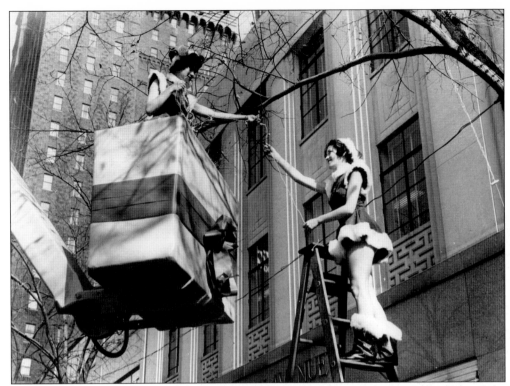

Attired in matching red outfits in November 1961, twins Jackie and Jerry Wright directed the placement of the miniature white lights on the trees in front of Saks Fifth Avenue, the retailer that originated the lighting of trees on North Michigan Avenue. (Courtesy of The Greater North Michigan Avenue Association.)

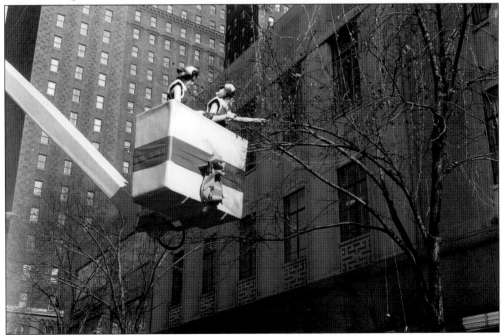

Compliments flooded in from throughout the world, praising the brilliance of North Michigan Avenue. B. E. Arnold, owner of Arnold's leather goods, formerly located at the site of the Marriott Hotel at Ohio Street and Michigan Avenue, said in a *Chicago Tribune* article, "People from all over the world would come into my shop around Christmastime and ask about the

little white lights. I think they're the greatest promotion Michigan Avenue ever had." He later remarked that a trip to Paris in the 1960s made him "suddenly feel like he was home in Chicago . . . They had decorated the Champs Elysees with those same tiny lights. I said to myself, 'I know where they got this idea.'" (Courtesy of United Press International.)

Hedda Hopper, "Looking at Hollywood" columnist for the *Chicago Tribune*, remarked on December 19, 1962, "I'm still glowing from three days in Chicago. Michigan Avenue was a fairyland of lights. The tall young elms along the avenue where the smart shops were veiled with miniature lights really got me. Years ago, before I ever left Altoona, PA, I used to read about Chicago's Gold Coast and thought, in my simple way, the sidewalks were paved with gold. Now it seemed to come true; not the pavements but the glittering trees with their golden lights." (Courtesy of Ron Schramm.)

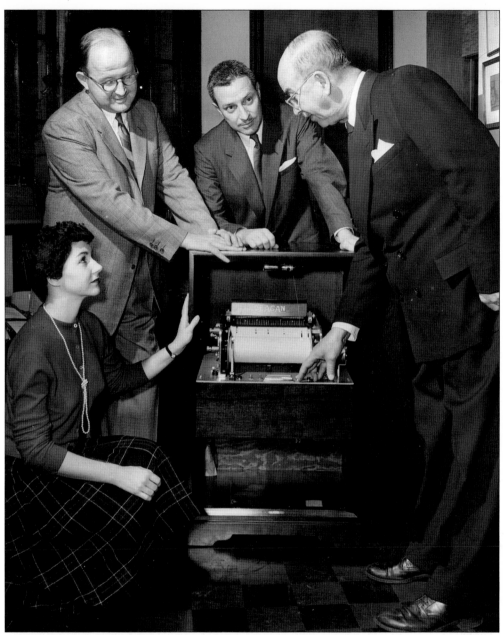

In addition to its striking illumination, The Magnificent Mile offered many other annual holiday traditions that embodied the spirit of the season. In 1947, the first of more than two decades of the Tribune Company's electronic carillon chime concerts floated down from the top of the Tribune Tower twice daily during the lunch hour and evening commute. The instrument, known as the Celesta-Chime, is pictured here with its owner, Jack C. Deagan (second from right), and others, including Nelson Forrest (second from left) of The Greater North Michigan Avenue Association. It is a two-and-a-half-octave keyboard, played by a perforated paper roll such as the one used on player pianos. In 1953, The Greater North Michigan Avenue Association added amplifiers to Water Tower Park so the daily Tribune Tower concerts could be enjoyed farther down the avenue. (Courtesy of The Greater North Michigan Avenue Association.)

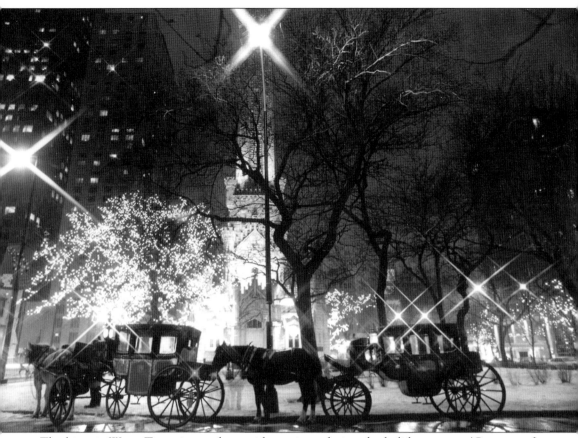

The historic Water Tower is seen here with carriages during the holiday season. (Courtesy of the Chicago Tribune.)

Three

THE MAGNIFICENT MILE
LIGHTS FESTIVAL

Once established, the widely popular tradition of tiny white lights glowing along North Michigan Avenue continued year after year, but the ceremonies to officially flip the switch to start the season fell by the wayside in the 1960s. That is, until 1992, when Marc Schulman, president of Eli's Cheesecake and the former Eli's the Place for Steak, had the vision to institute not just the pull of a single switch to light the avenue but a block-by-block procession to illuminate the streetscape and kick off the season.

Schulman gathered a committee of leaders from The Magnificent Mile district to develop this new, more elaborate holiday event concept. Their vision was to create an exciting affair that would bring people together along North Michigan Avenue to make merry and witness a more involved and more dramatic illumination of its white tree lights. Drawing on the district's central attribute, a magnificent and mile-long avenue, Schulman and the committee planned a visual procession of carriages that would travel down the length of the street from Oak Street to the Michigan Avenue bridge, pausing to illuminate each block, one by one, with onlookers "counting down to lights" at each stop along the way.

Rick Kogan, in an article titled, "It's time to turn on the lights," in the *Chicago Tribune* in November 1992, talked with Schulman who remarked, "It's all meant to be fun, to really kick-off the holiday season in a style reminiscent of bygone days." Kogan recalled watching some city workers string tiny lights around the bare branches of the trees along North Michigan Avenue. The worker said of stringing the lights, "I do this carefully. This is my favorite job all year." Kogan concurred, "We understand. Seeing the lights brighten Michigan Avenue is one of our favorite things to see all year, a sure sign that they city's streets will soon be alive with holiday happenings."

The 1992 committee capped its illumination procession with a grand finale celebration and fireworks show in the great open space of Pioneer Court. From this first-year event grew the ever-evolving holiday celebration that is The Magnificent Mile Lights Festival, attended annually by one million guests and watched by millions more on its nationally televised broadcast.

November 21, 1992, marked the first Michigan Avenue holiday lights festival, taking place at dusk with a procession of horse-drawn carriages that traveled from Oak Street to the Chicago River. Michigan Avenue's famed boulevard of twinkling trees was illuminated block by block as the carriages passed, carrying The Greater North Michigan Avenue Association and city leaders, well-known media personalities Linda McClennon and Bill Zwecker, and presiding celebrity Jamie Farr. Farr received a star on the Hollywood Walk of Fame in 1985 and an Emmy nomination for his work on the television series M*A*S*H. The festivities also included the toy soldier from FAO Schwarz and Santa Claus, seen here in Water Tower Park. (Above, courtesy of Stanley Wlodkowski; left, courtesy of The Greater North Michigan Avenue Association.)

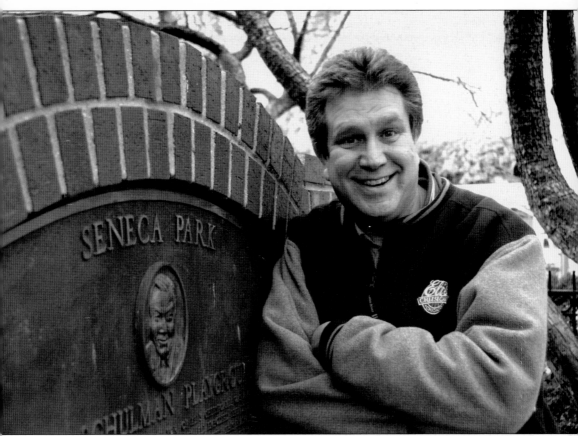

Holiday events continued beyond the November 21 kick off with a "Winter Picnic in the Park," featuring Santa, carolers, and storybook characters at Water Tower Park on Saturdays and Sundays during December. Also, the Chicago Park District presented choirs and dancers at the Eli M. Schulman Playground in Seneca Park, with hot chocolate and cider provided by Eli's the Place for Steak. The playground at Seneca Park, located just east of Chicago's Water Tower and pumping station, is named in honor of Eli M. Schulman, a well-known community advocate, business leader, and father of Marc Schulman, founding chairman of The Magnificent Mile Lights Festival. (Courtesy of Maureen Schulman.)

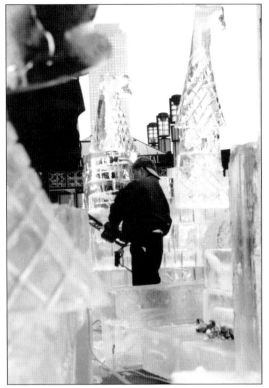

The InterContinental Chicago orchestrated the first annual giant ice carving outside the hotel. Master carver Gervacio Marcelo and a five man ice-carving team prepared for weeks in advance of the live carving, determining which images to carve and the amount of ice required. More than 4,000 pounds of ice were delivered to the InterContinental Chicago. A wood carver by trade, Marcelo used intricate wood-carving techniques and a chain saw to create the ice carvings. The spectacle of the saws spewing ice 10 feet into the air attracted overwhelming attention. The live ice carvings continue today as a popular offering of The Magnificent Mile Lights Festival but have moved from the front of the hotel to a closed side street and put on a stage to accommodate the many spectators. (Left, courtesy of the Chicago Tribune; below, courtesy of Karen I. Hirsch.)

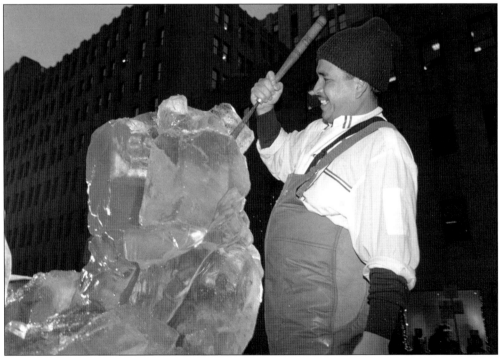

Inspired by the positive public response to the first Lights Festival, the committee developed grander plans for the 1993 event. The second-year highlight was a motorcade of antique cars, complete with Santa, elves, celebrities and VIPs to light the trees along The Magnificent Mile, including American film and television actor and director Robert Conrad, American Tony Award-winning actor of film, stage, and television Joe Mantegna, along with Joe Pantoliano and Brian Haley, all in Chicago to film the movie *Baby's Day Out*, as well as ABC 7's Janet Davies. (Above, courtesy of Ron Schramm; below, courtesy of Maureen Schulman.)

Haley, Kori, and Elana Schulman pose with Miss Illinois 1993 Sara Martin in the Equitable Building Plaza, now known as Pioneer Court. (Courtesy of Maureen Schulman.)

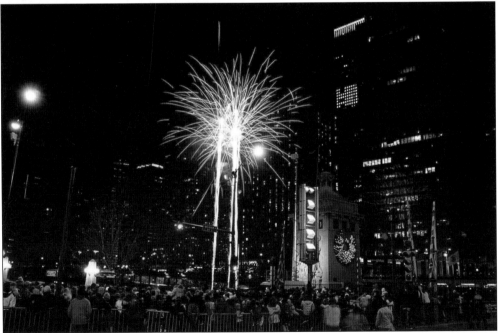

A fireworks show over the Chicago River at the Michigan Avenue bridge concluded the festivities. Not only did the event draw record crowds, it was also televised locally on ABC 7 Chicago. (Courtesy of Stanley Wlodkowski.)

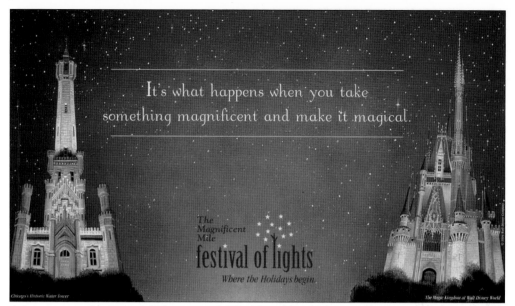

It's what happens when you take
something magnificent and make it magical.

The Magnificent Mile
festival of lights
Where the Holidays begin.

Advertising in the *Chicago Tribune* stated, "On November 19th, see what happens when you take something magnificent and make it magical." In 1994, the Walt Disney World Resort joined as a partner of The Magnificent Mile Lights Festival. With Disney characters and themes to enhance Chicago's kick off to the holiday season, event attendance blossomed to 250,000 visitors. (Courtesy of The Greater North Michigan Avenue Association; © Disney Enterprises, Inc.)

"Disney's magic makes this holiday season's opening truly extraordinary," said Schulman, owner of Eli's Cheesecake Company and founding chairman of The Magnificent Mile Lights Festival, pictured here on a sunny day in Water Tower Park with cochairman, Heinz Kern (right), and crowd favorite, Mickey Mouse. (Courtesy of The Greater North Michigan Avenue Association; Mickey Mouse © Disney Enterprises, Inc. Used by permission from Disney Enterprises, Inc.)

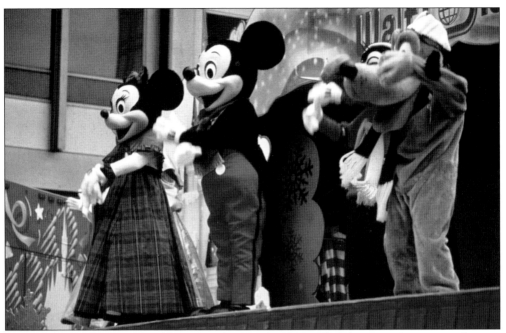

Produced by Walt Disney World Resort talent in Florida, live holiday stage shows riveted guests of The Magnificent Mile Lights Festival in Pioneer Court at noon, 2:00 p.m., and 4:00 p.m. on the afternoon of November 21, 1994. Mickey Mouse, Minnie Mouse, Goofy, Snow White, Dopey, Pluto, Cinderella's Fairy Godmother, and Frosty the Snowman performed on a large, colorful stage built especially for the Chicago venue. Local dancers were recruited to support the choreographed show content, which featured lively songs and pyrotechnic effects. (Courtesy of the Chicago Tribune; Disney characters © Disney Enterprises, Inc. Used by permission from Disney Enterprises, Inc.)

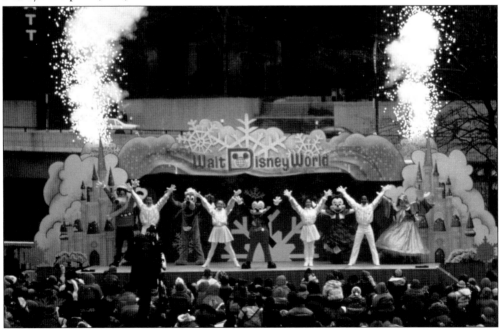

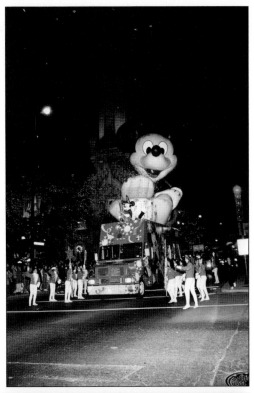

At dusk, a glittering procession featured favorite Disney characters, magical Disney vehicles, a marching band, dancing elves, and Santa. In his role as the Sorcerer's Apprentice from Walt Disney's *Fantasia*, Mickey Mouse waved his lighted magic wand in front of a 26-foot inflatable statue of himself and illuminated each block of white tree lights. To punctuate each block's illumination, reflective confetti magically shot from Mickey's vehicle, to the delight of city residents and visitors gathered along the sidewalks. (Right, courtesy of Stanley Wlodkowski; below, courtesy of the Chicago Tribune; Mickey Mouse © Disney Enterprises, Inc. Used by permission from Disney Enterprises, Inc.)

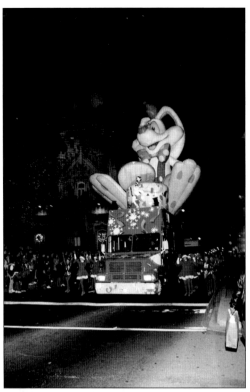

Roger Rabbit, in his bright-red overalls, followed Mickey down Michigan Avenue in 1994 on his own vehicle with his giant inflatable statue towering overhead. (Courtesy of Stanley Wlodkowski; Roger Rabbit © Touchtone Pictures and Amblin Entertainment, Inc. Used by permission from Disney Enterprises, Inc.)

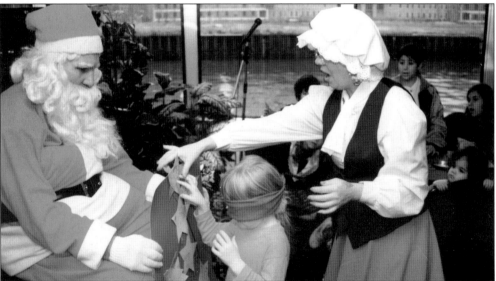

Chicago's First Lady offered candy cane cruises in 1994, the first and only time in its history the company operated during the holiday season. On weekends from November 25 through December 18, two-hour candy cane cruises set sail at 2:00 p.m. from the Mercury dock at the lower level of Michigan Avenue bridge at the Chicago River. Kids on board met Santa and Mrs. Claus and munched on gingerbread cookies and peppermint ice-cream sundaes as streams of holiday favorites sounded from the ship's player piano. (Courtesy of Chicago's First Lady Cruises.)

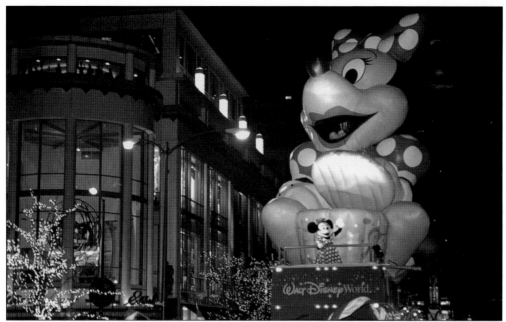

A larger-than-life Minnie Mouse was a new addition to The Magnificent Mile Lights Festival in 1995. She joined Mickey Mouse, who ceremoniously led the lighting of North Michigan Avenue, donning his Sorcerer's Apprentice costume and waving his magic wand for the record-setting crowd of 400,000 guests in attendance. Behind him, Minnie, followed by her 30-foot-tall inflatable self, greeted the crowds with cheerful wishes and kisses, riding high on her holiday float and flanked by high school drill teams stepping to the music. (Courtesy of Karen I. Hirsch; Disney characters © Disney Enterprises, Inc. Used by permission from Disney Enterprises, Inc.)

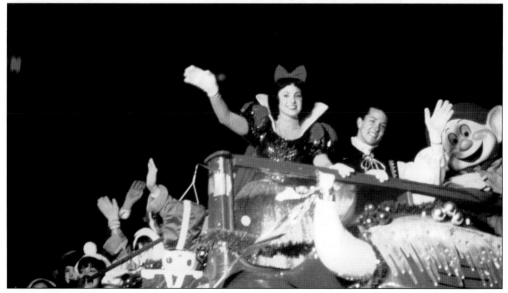

Goofy, Snow White, and other Disney characters that performed earlier in the day, waved to the crowd from brightly decorated double-decker buses. (Courtesy of Stanley Wlodkowski; (Courtesy of Karen I. Hirsch; Disney characters © Disney Enterprises, Inc. Used by permission from Disney Enterprises, Inc.)

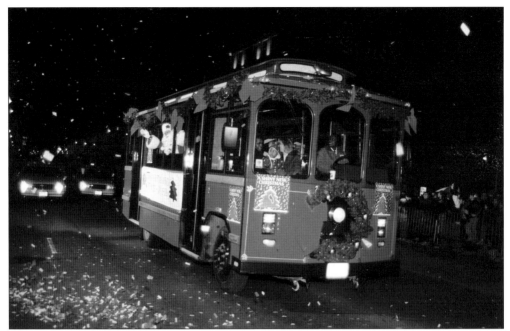

Santa arrived as the final guest of honor aboard a trolley. A feature of every Magnificent Mile Lights Festival, the buses owned by Chicago Trolley and Double Decker Company transport characters, bands, and association members down the procession route high enough for even the smallest parade-goers to see. (Courtesy of Stanley Wlodkowski.)

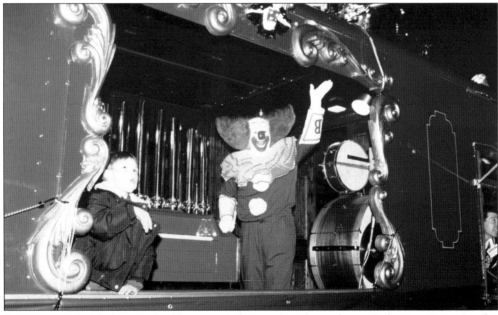

A 1925 one-of-a-kind musical calliope carried Bozo the Clown, host of *The Bozo Super Sunday Show* on WGN-TV Channel 9. The calliope was presented in cooperation with Jasper B. Sanfilippo, the president, chairman of the board, and chief executive officer of John B. Sanfilippo and Son, who was also the owner and collector of musical machines. (Courtesy of the Chicago Tribune.)

Kirk Cameron, star of the former WB show *Kirk*, coanchored with Allison Payne on WGN-TV Channel 9's live broadcast of The Magnificent Mile Lights Festival. Beloved weatherman Tom Skilling, as an on-the-street reporter, began the tradition of canvassing the ever-growing crowds of visitors lining the procession route. (Above, courtesy of the Chicago Tribune; below, courtesy of Stanley Wlodkowski.)

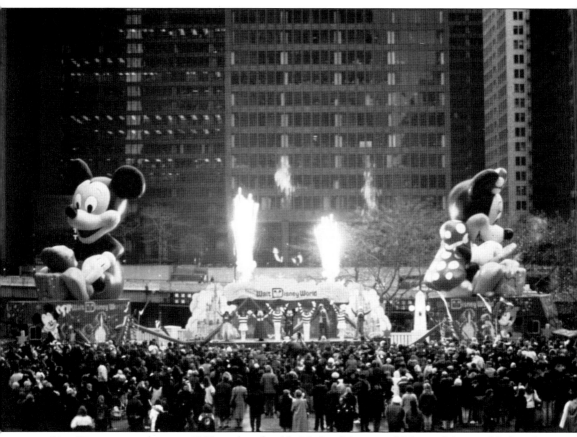

Live Disney stage shows in 1995, with inflatable Mickey Mouse and Minnie Mouse added to the backdrop, featured Mickey Mouse, Minnie Mouse, Goofy, Pluto, Snow White, Roger Rabbit, the Fairy Godmother, and other Disney characters in a show titled, *A Disney Magical Holidays Celebration*. (Courtesy of the Chicago Tribune; Disney characters © Disney Enterprises, Inc. Roger Rabbit © Touchtone Pictures and Amblin Entertainment, Inc. Used by permission from Disney Enterprises, Inc.)

Minnie Mouse greets an excited fan in Pioneer Court. (Courtesy of The Greater North Michigan Avenue Association; Minnie Mouse © Disney Enterprises, Inc. Used by permission from Disney Enterprises, Inc.)

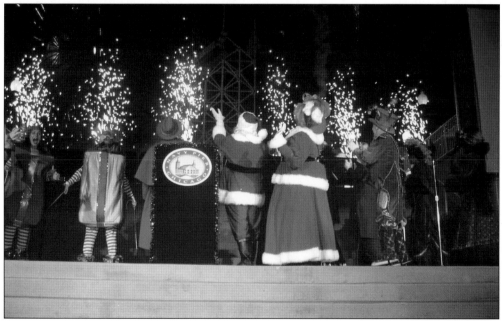

Santa spent a second day celebrating the holiday season in The Magnificent Mile district with a ride upon the Christmas Tree Boat to nearby Navy Pier. There he spent time with children in the Crystal Gardens, an indoor botanic garden specially decorated for the holiday season. The glass-enclosed Crystal Gardens featured poinsettia displays and other holiday greenery in addition to its 71 live palm trees and dancing fountains. (Courtesy of Navy Pier.)

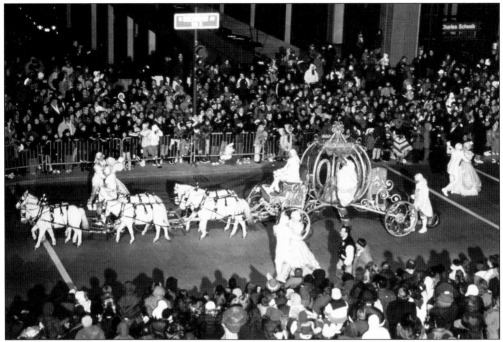

On Saturday, November 23, 1996, a half-million guests attended the ceremonial lighting of trees, which was punctuated by the debut of Cinderella and her coach, complete with coachman and tiny white horses. Cinderella was present to commemorate Walt Disney World Resort's 25th anniversary celebration. Her arrival marked the first time Cinderella's coach had ever left the Walt Disney World Resort property. (Courtesy of the Chicago Tribune; Disney characters © Disney Enterprises, Inc. Used by permission from Disney Enterprises, Inc.)

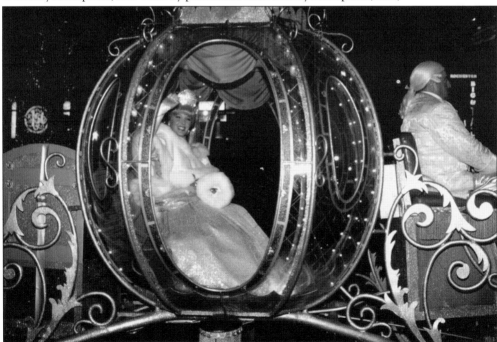

In front of the grand holiday tree in its lobby, the 900 Shops presented mini performances of the Chicago Tribune Charities Fund's *The Nutcracker*. (Courtesy of the Chicago Tribune and the 900 Shops.)

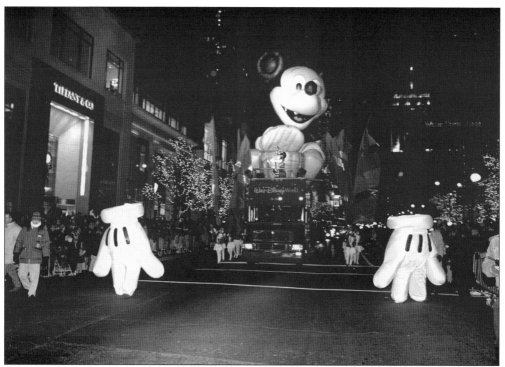

Whimsical marching Mickey gloves came to life to accompany Mickey down Michigan Avenue in 1997, as well as a walking cap with Mickey ears. (Courtesy of Karen I. Hirsch; Disney characters © Disney Enterprises, Inc. Used by permission from Disney Enterprises, Inc.)

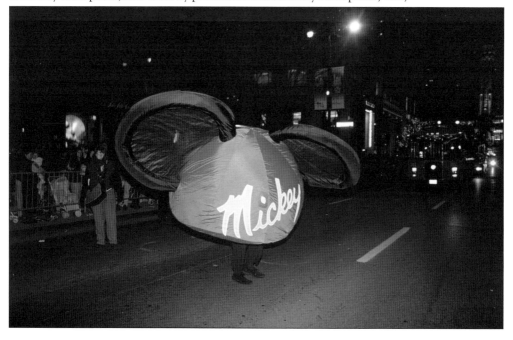

The Tribune Company commissioned artist John David Mooney to illuminate the Tribune Tower to celebrate its 150th anniversary in June 1997. Titled Light Muse, Mooney's design called for 1,650 colored lights placed in the neo-gothic tower's windows, achieving a stained-glass effect. As an encore presentation, the Tribune Tower was magically transformed again into a towering light sculpture for The Magnificent Mile Lights Festival in 1997, pictured as Cinderella's coach passed by. (Right, courtesy of Karen I. Hirsch; below, courtesy of the Chicago Tribune; Disney characters © Disney Enterprises, Inc. Used by permission from Disney Enterprises, Inc.)

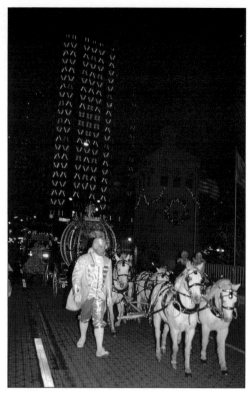

Adjacent to the Disney stage-show area, kids mingled with live, miniature reindeer and clowned around at the WGN Radio 720 AM's Winter Walk in Pioneer Court. Attendees enjoyed hot chocolate, carolers, jugglers, stilt walkers, and more. (Courtesy of the Chicago Tribune.)

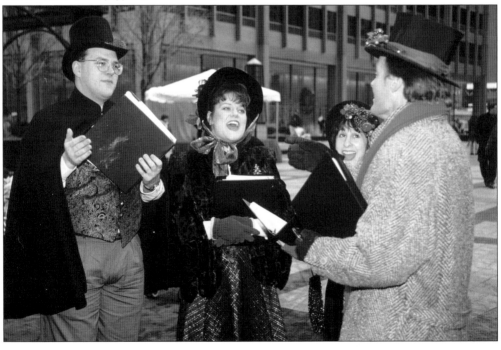

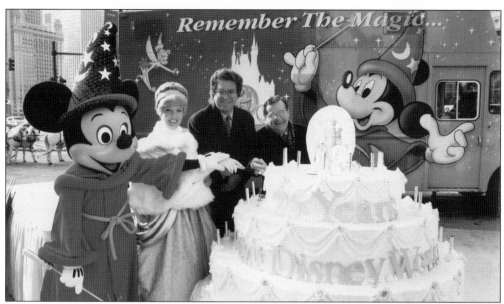

One of the most popular features of WGN Radio 720 AM's Winter Walk in Pioneer Court was the Eli's Cheesecake tent. Adopting a different theme each year, Eli's pastry teams have created cakes weighing as much as 500 pounds and standing four and a half feet tall. One cake, titled, Eli's Giant Gingerbread Village, incorporated 200 pounds of gingerbread, 150 pounds of royal icing, 75 pounds of chocolate, and 75 pounds of candy. In 1996, Eli's created a cake to commemorate Walt Disney World Resort's 25th anniversary and the first arrival of Cinderella and her coach at The Magnificent Mile Lights Festival. In recent years, Eli's Cheesecake has partnered with the Chicago High School for Agricultural Sciences, the only public high school in Illinois located on a working farm, to raise funds and food donations for the Chicago Food Depository at the Magnificent Mile Lights Festival. (Courtesy of Eli's Cheesecake Company and the Chicago Tribune; Disney characters © Disney Enterprises, Inc. Used by permission from Disney Enterprises, Inc.)

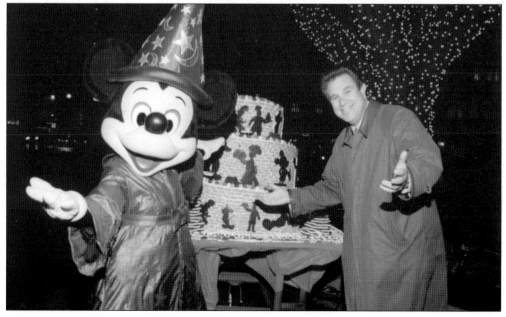

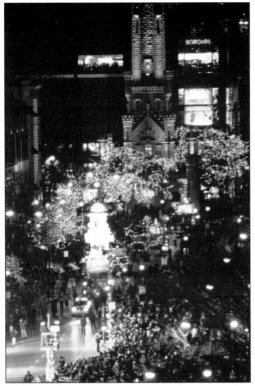

Animal prints were in high fashion during the holiday season in 1998, as Safari Mickey Mouse and Rafiki, a shamanistic monkey from Disney's *The Lion King*, and their friends from Disney's Animal Kingdom Park traveled to Chicago to promote the opening of Walt Disney World Resort's new theme park, Disney's Animal Kingdom. Joining the celebration, from left to right, are Grant DePorter of Harry Caray's restaurants, Marc Schulman of Eli's Cheesecake, Alderman Burt Natarus, Michael Christ of Tiffany and Company and chairman of The Greater North Michigan Avenue Association, Russell Salzman, and Tony Suttile of the Pioneer Inn and Marina. Daytime stage shows ended with a wild new finale featuring music from Disney's *The Lion King* and entertainment from Disney's Animal Kingdom Park, which opened in April 1998. (Left, courtesy of the Chicago Tribune; below, courtesy of Stanley Wlodkowski; Disney characters © Disney Enterprises, Inc. Used by permission from Disney Enterprises, Inc.)

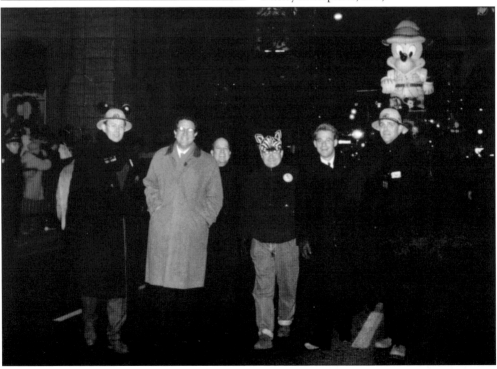

A dinosaur-sized vehicle brought a prehistoric bit of DinoLand USA from Disney's Animal Kingdom Park to the Midwest's main street for the 1998 holiday season. (Courtesy of Ron Schramm; Used by permission from Disney Enterprises, Inc.)

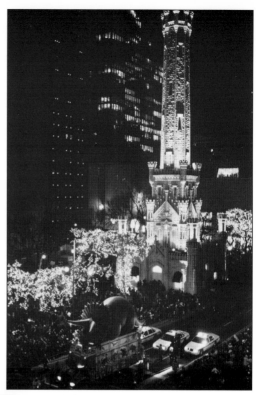

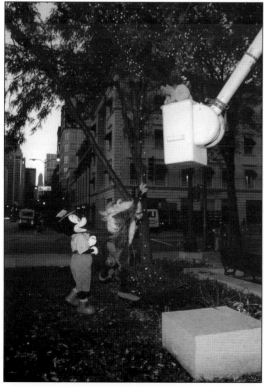

Safari Mickey and Rafiki supervised the stringing of the lights on the trees in Water Tower Park. One million lights are strung on 200 trees along North Michigan Avenue in preparation for The Magnificent Mile Lights Festival. Stringing of the lights begins six weeks prior to their illumination. (Courtesy of Stanley Wlodkowski; Disney characters © Disney Enterprises, Inc. Used by permission from Disney Enterprises, Inc.)

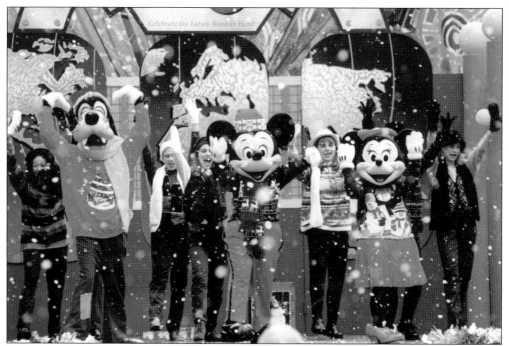

"Millennium Magic on The Magnificent Mile" was the theme in 1999. At 11:00 a.m., 1:00 p.m., and again at 3:00 p.m. on November 20, Disney presented live stage shows titled *Millennium Magic* in honor of Walt Disney World Resort's 15-month millennium celebration. In the stage shows, Mickey Mouse and friends went in search of millennium traditions. These shows were enhanced by special effects, including snow machines and pyrotechnics. (Courtesy of the Chicago Tribune; Disney characters © Disney Enterprises, Inc. Used by permission from Disney Enterprises, Inc.)

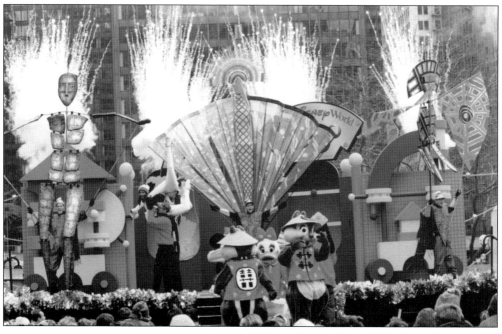

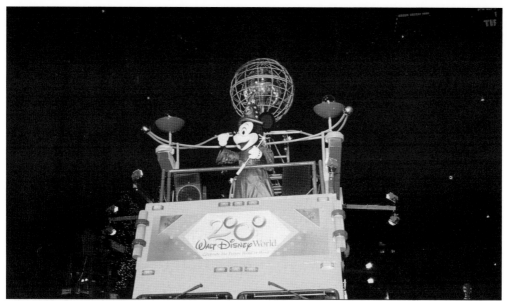

The 1999 procession had Mickey atop one of two millennium vehicles outfitted with lights, torches and drums, patterned after part of the Tapestry of Nations at World Showcase at Epcot. Perched on the second vehicle in the procession, live drummers kept the magical beat of the procession. Tapestry of Nations puppets walked alongside these millennium vehicles. The puppets debuted earlier in the day during the *Millennium Magic* stage show. As the lighting procession traveled south on Michigan Avenue, Mickey Mouse asked the crowd of 800,000 to help him create enough millennium magic to light the lights along The Magnificent Mile. With the cheers and wishes of the spectators, Mickey lit a huge mirrored ball atop the vehicle and the lights on the trees up and down North Michigan Avenue, officially marking the start of the holidays in Chicago. (Courtesy of Stanley Wlodkowski; Disney characters © Disney Enterprises, Inc. Used by permission from Disney Enterprises, Inc.)

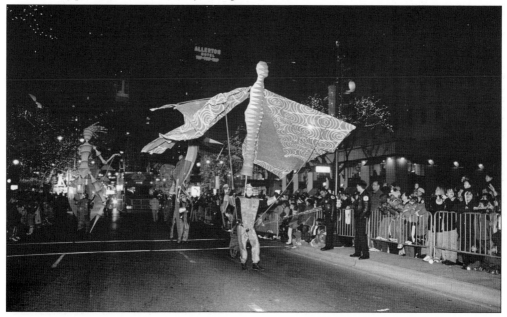

The smell of chestnuts roasting filled Water Tower Park, as horse-drawn carriages conducted tours. (Courtesy of The Greater North Michigan Avenue Association.)

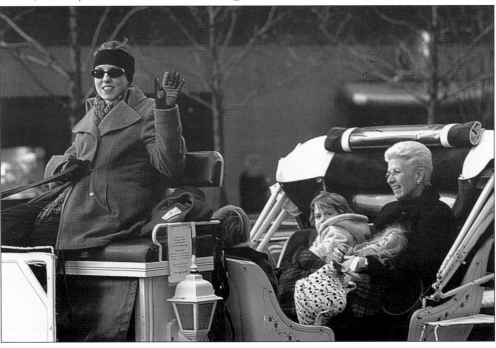

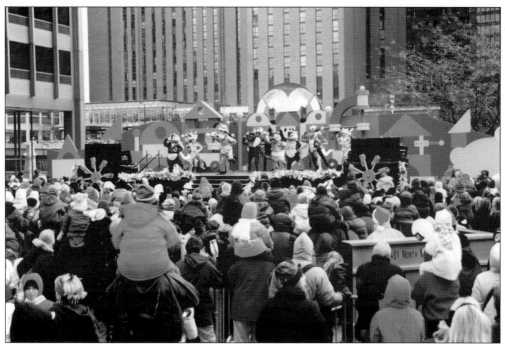

Visitors enjoyed a new Disney-produced stage show at the ninth-annual Magnificent Mile Lights Festival in 2000, titled *Holiday Dreams*, including a cast of characters who helped Minnie Mouse, Mickey, and their friends enact their dreams, while Chip and Dale kept the holiday songs coming. (Courtesy of Dave Rench; Disney characters © Disney Enterprises, Inc. Used by permission from Disney Enterprises, Inc.)

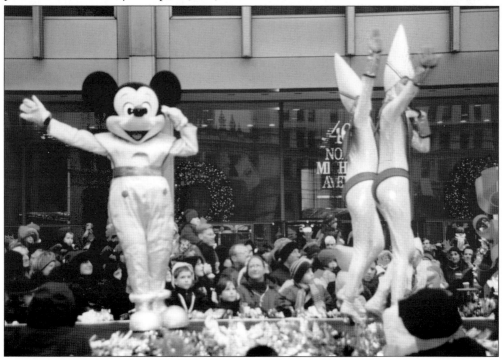

Each year, The Magnificent Mile Lights Festival includes the unveiling of elaborate holiday windows, judged by members of the art community in Chicago. American Girl Place's holiday windows draw admirers from all over the country. American Girl has won kid's choice, most entertaining, and best use of technology awards from the panel of holiday window judges from The Greater North Michigan Avenue Association. (Courtesy of American Girl Place.)

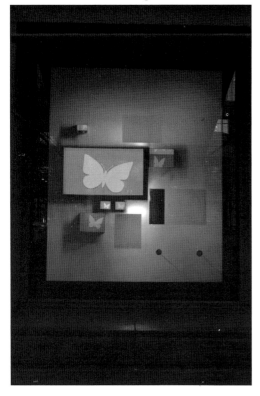

Neiman Marcus's butterfly symbol jumped off an illuminated screen featured in the windows at 737 North Michigan Avenue. Neiman Marcus won an award for best use of color. (Courtesy of The Greater North Michigan Avenue Association.)

Paul Stuart, located in the John Hancock Center at 875 North Michigan Avenue, adopted a Windy City theme with this window display. Stuart has won most dramatic and best execution of theme window awards. (Courtesy of The Greater North Michigan Avenue Association.)

On the corner of Superior and Michigan Avenues, Tiffany and Company features windows that are small in size but offer a large visual impact. Creative themes showcase their singular jewelry offerings, earning Tiffany's a best of show award for three years in a row. (Courtesy of Tiffany and Company.)

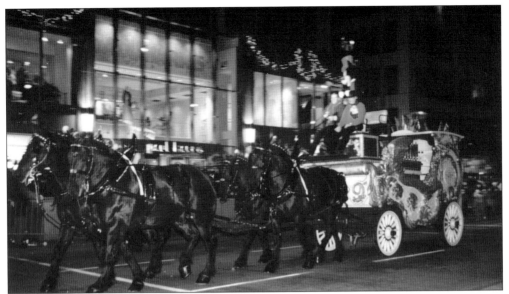

Mickey Mouse wore his holiday finery to the 2000 Magnificent Mile Lights Festival, riding atop a festive calliope pulled by six enormous Percheron horses. This particular calliope was originally built in England more than 100 years ago and is still in perfect working order. It was originally used in the Disney film *Toby Tyler and the Circus* and since then has been used in many parades and processions at Walt Disney World Resort and around the country. (Courtesy of Stanley Wlodkowski; Disney characters © Disney Enterprises, Inc. Used by permission from Disney Enterprises, Inc.)

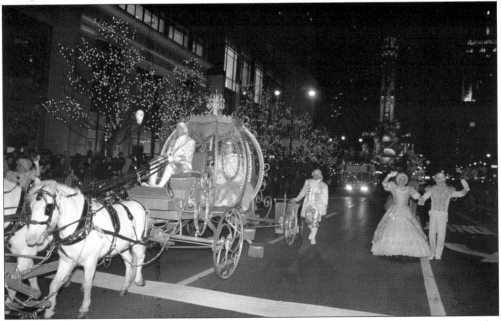

The most beautiful girl at the ball, Cinderella, returned for another royal ride down The Magnificent Mile in her magical coach, accompanied by her Fairy Godmother, Prince Charming, and court dancers performing a minuet on The Magnificent Mile. (Courtesy of Karen I. Hirsch; Disney characters © Disney Enterprises, Inc. Used by permission from Disney Enterprises, Inc.)

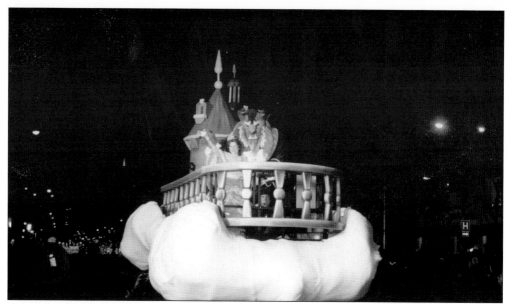

Two dreamlike floats filled with romance, featuring Belle and the Beast and Snow White and her Prince, arrived next. Snow White and her Prince rode alongside the Wishing Well, accompanied by Dopey. Belle and the Beast were dressed up for their own private ball on the balcony of the Beast's enchanted castle, sitting atop the clouds. (Courtesy of Stanley Wlodkowski; Disney characters © Disney Enterprises, Inc. Used by permission from Disney Enterprises, Inc.)

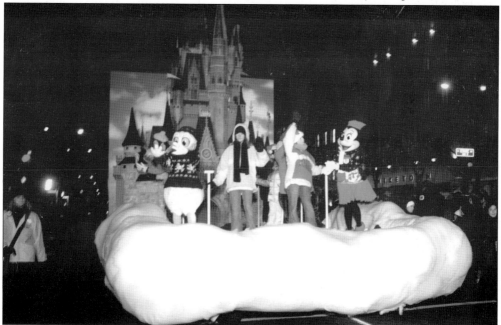

The final Disney float was Cinderella Castle, filled with more favorite Disney characters, including Minnie Mouse, Donald and Daisy Duck, Chip and Dale, and Goofy, direct from Walt Disney World Resort in Florida. This replica of Cinderella Castle was almost 30 feet tall. (Courtesy of Stanley Wlodkowski; Disney characters © Disney Enterprises, Inc. Used by permission from Disney Enterprises, Inc.)

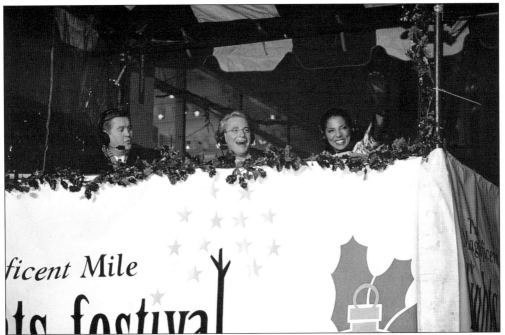

Russ Salzman (center), president and chief executive officer of The Greater North Michigan Avenue Association, joined Allison Payne and Steve Sanders in the television booth for the live broadcast of the lights festival on WGN-TV Channel 9. (Courtesy of Stanley Wlodkowski.)

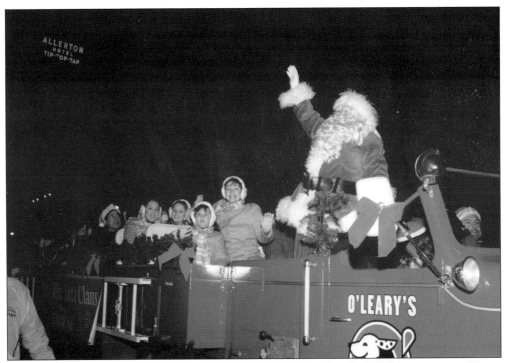

Always the last celebrity of the annual procession, Santa ushered in the holiday season on a "Home for the Holidays" fire truck rather than on his sleigh. (Courtesy of Stanley Wlodkowski.)

Harry Caray's Italian Steakhouse, named for the late hall of fame baseball announcer, opened its flagship location at Dearborn and Kinzie Streets in 1987 and is filled with nostalgic sports items and photographs of celebrities who call this restaurant a favorite. Paying homage to the beloved announcer, many who visit the restaurant stop to pose for a photograph with Caray's bust. (Courtesy of Harry Caray's restaurants.)

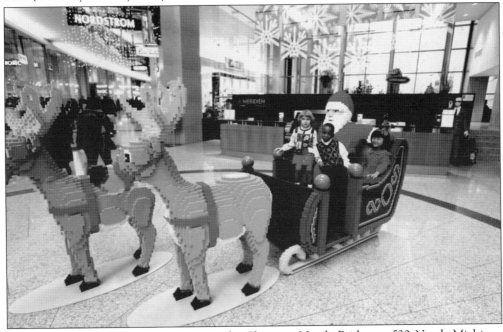

A giant LEGO Santa greets visitors at the Shops at North Bridge at 520 North Michigan Avenue, which opened on The Magnificent Mile in 2000. Created from traditional and LEGO Duplo bricks, Rudolph, with his shiny, glowing nose, and Prancer pull Santa's intricate sleigh. (Courtesy of the Shops at North Bridge.)

Winter Wonderfest is an annual transformation of Navy Pier into a holiday wonderland. Popular features include a 50-foot-high indoor Ferris wheel, a reindeer express trackless train, inflatable slides, and an arctic ice rink filled with 13,325 gallons of ice. (Courtesy of Navy Pier.)

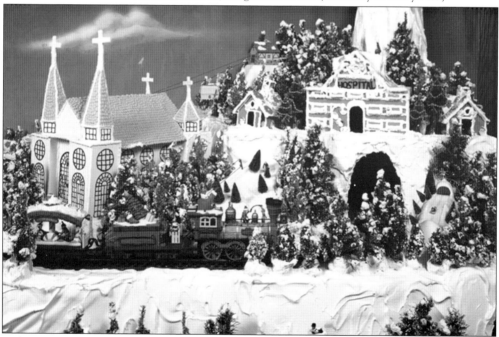

Fashioned by the hotel's talented chef staff, a train wound its way through a village of gingerbread houses, marzipan mountains, and valleys of chocolate on display in the lobby of the Drake Hotel Chicago at Walton and Michigan Avenues. This fanciful creation was fashioned by the talented chef staff of the Drake Hotel. (Courtesy of the Drake Hotel Chicago.)

A real-bearded Santa against a lavishly decorated north pole backdrop drew guests to the 900 Shops, located at 900 North Michigan Avenue. (Courtesy of the 900 Shops.)

The lobby of the Talbott Hotel, a boutique hotel built in 1927 at 20 East Delaware Street, offers a cozy and festive respite from holiday shopping. (Courtesy of the Talbott Hotel.)

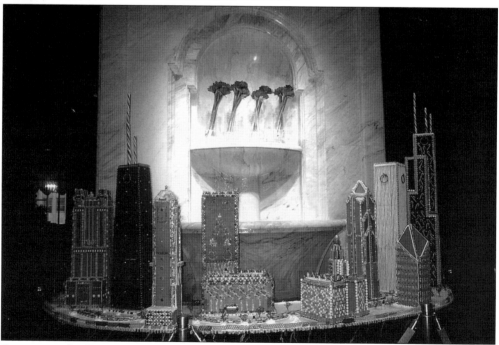

Every year, the Four Seasons Hotel Chicago on Delaware and Michigan Avenue displays a gingerbread creation in its lobby, including a realistic skyline of the city of Chicago. (Courtesy of the Four Seasons Hotel Chicago.)

A 15-foot gingerbread chalet was displayed in the lobby of Swissôtel Chicago, located at 323 East Wacker Drive. Developed by the Swissôtel chef staff, the chalet was large enough for children to step inside, enjoy holiday gingerbread cookies, write a letter to Santa, and sit by a candy holiday tree. It was decorated with 400 pounds of chocolate, 300 pounds of gingerbread, 600 pounds of candy, 100 pounds of marshmallow treats, and 100 pounds of meringue. (Courtesy of Swissôtel Chicago.)

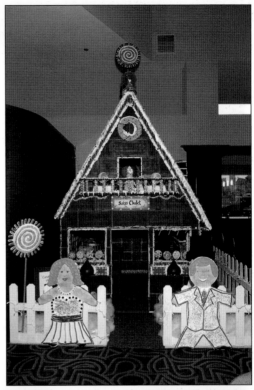

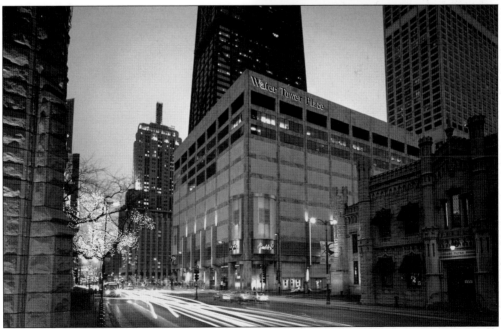

The interior of Water Tower Place near Water Tower Park at 835 North Michigan Avenue is an eight-level atrium featuring more than 100 stores, specialty shops, boutiques, and restaurants. Elaborate holiday decor is suspended in the atrium during the holiday season. (Courtesy of Water Tower Place.)

With crowds reaching record numbers each year, the Magnificent Mile Lights Festival volunteer committee responded in 2001 by adding performances along the lighting procession route on each block from Oak Street to Wacker Drive to entertain guests before Mickey's arrival. (Courtesy of the Chicago Tribune.)

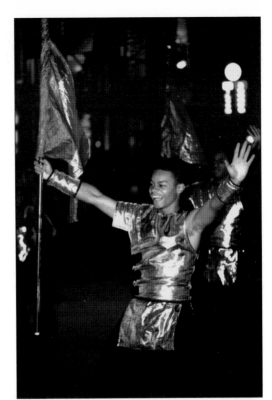

Live, interactive holiday acts included the Radio City Rockettes, Ringling Brothers Circus, and local organizations such as the South Shore Drill Team, the Jesse White Tumblers, the Happiness Club, and many more. (Courtesy of the Chicago Tribune.)

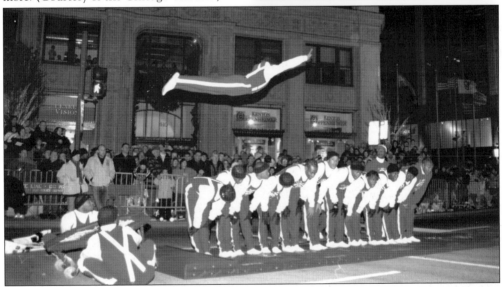

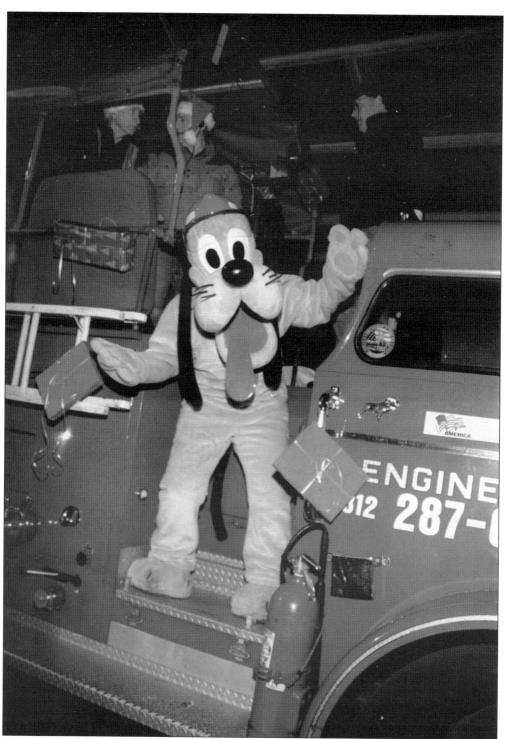

More than 900,000 guests enjoyed the procession in 2001, as Pluto led the way on a 1949 antique fire truck. (Courtesy of Stanley Wlodkowski; Disney character © Disney Enterprises, Inc. Used by permission from Disney Enterprises, Inc.)

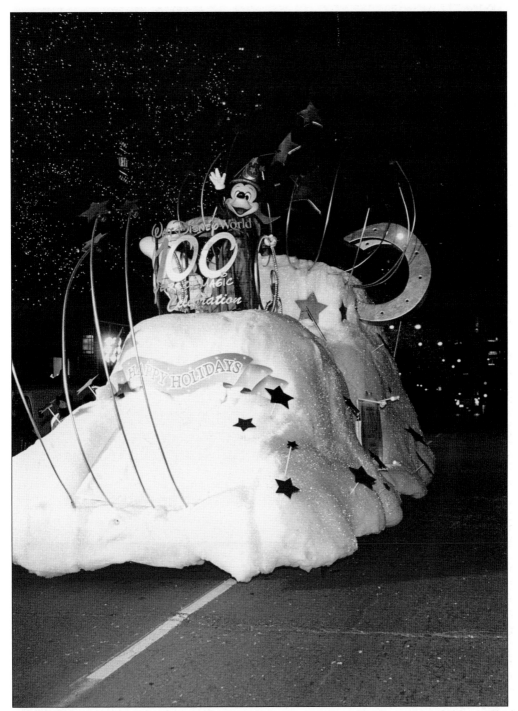

The master of ceremonies, Mickey Mouse, followed on a new 100 Years of Magic float. The Sorcerer's hat on Mickey's vehicle symbolized a 15-month celebration at Walt Disney World Resort in Florida, honoring the 100th birthday of Walt Disney, born in Chicago in 1901. (Courtesy of the Chicago Tribune; Disney characters © Disney Enterprises, Inc. Used by permission from Disney Enterprises, Inc.)

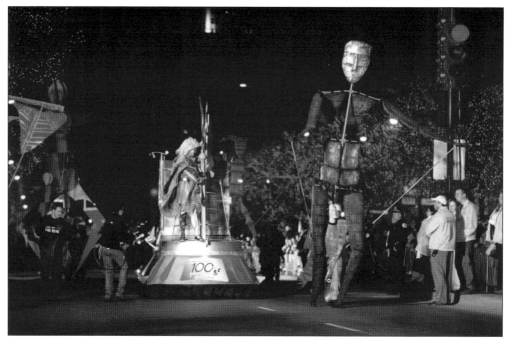

The Tapestry of Dreams vehicle was a salute to humankind's power to dream and create. Featuring Leonardo the Dream Spinner on board, the vehicle moved down Michigan Avenue in 2001 while its puppets interacted with guests along the route. (Courtesy of the Chicago Tribune; Disney characters © Disney Enterprises, Inc. Used by permission from Disney Enterprises, Inc.)

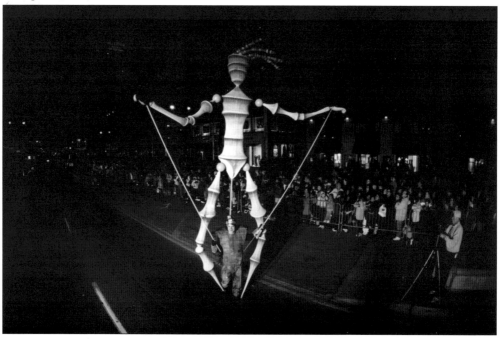

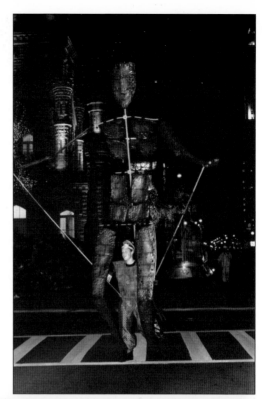

Designed by Michael Curry, the creator of the puppets for the Lion King on Broadway, the 18-foot Tapestry of Dreams puppets each had their own distinct personalities and were made of cloth, metal, and paint. (Courtesy of the Chicago Tribune; Disney characters © Disney Enterprises, Inc. Used by permission from Disney Enterprises, Inc.)

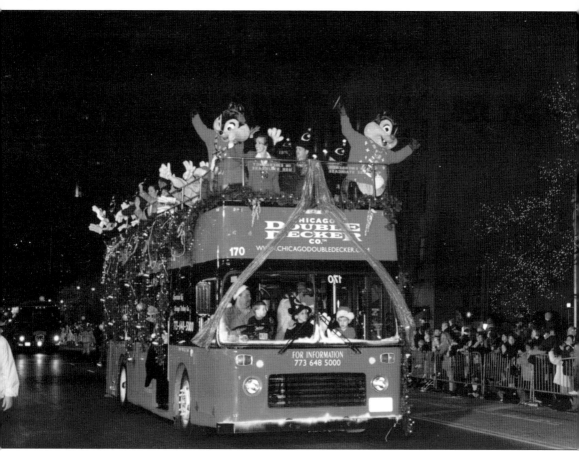

Chip and Dale energized the crowds as they passed by on the top of a Chicago Double Decker Company bus. (Courtesy of the Chicago Tribune; Disney characters © Disney Enterprises, Inc. Used by permission from Disney Enterprises, Inc.)

From a nearby suburban high school, the Glenbrook South marching band, which has performed at the Rose Bowl, the Orange Bowl, and the Cotton Bowl, was a frequent participant of Magnificent Mile Lights Festival activities. (Courtesy of the Chicago Tribune.)

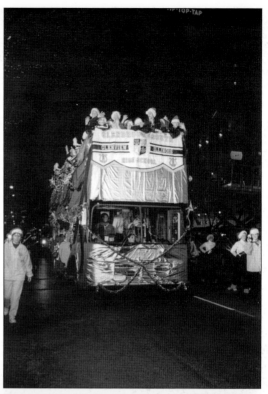

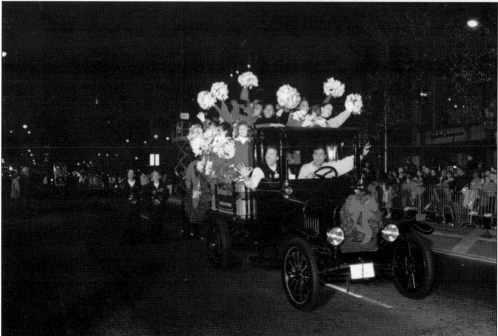

The *Chicago Tribune*'s 75-year-old antique Model T delivery wagon was back for its fifth year, carrying the Luv-A-Bulls and Junior Luv-A-Bulls, who entertain at every Chicago Bulls home game at the United Center. (Courtesy of the Chicago Tribune.)

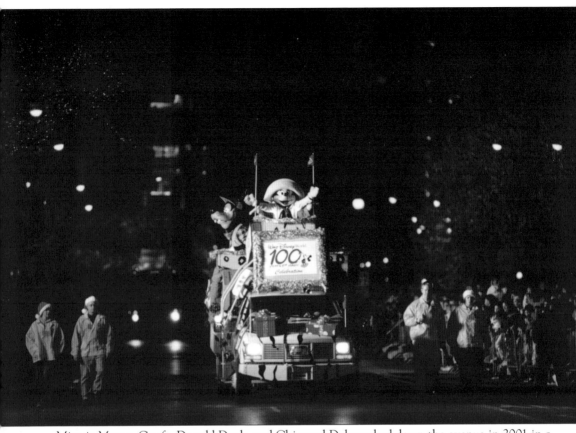

Minnie Mouse, Goofy, Donald Duck, and Chip and Dale rocked down the avenue in 2001 in a jungle Jeep from Mickey's Jammin' Jungle parade at Disney's Animal Kingdom Park escorted by volunteers of The Magnificent Mile Lights Festival. (Courtesy of the Chicago Tribune; Disney characters © Disney Enterprises, Inc. Used by permission from Disney Enterprises, Inc.)

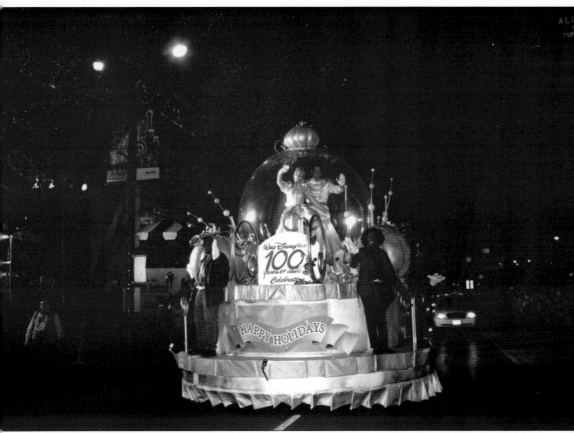

Direct from the Magic Kingdom Park at Walt Disney World Resort, the Share a Dream Come True float was a larger-than-life snow globe, carrying Cinderella and Prince Charming as they waltzed the night away. Also on board were contest winners of a sweepstakes from Walt Disney World Resort and WGN-TV Channel 9. (Courtesy of the Chicago Tribune; Disney characters © Disney Enterprises, Inc. Used by permission from Disney Enterprises, Inc.)

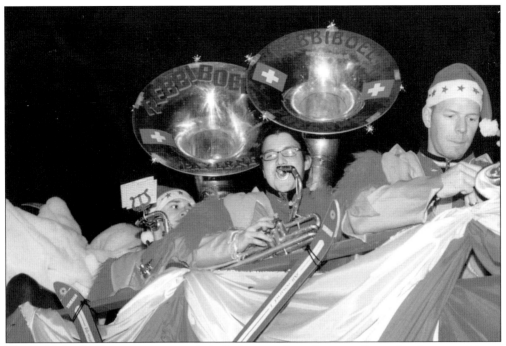

The Rebbiboel's Guggenmusig traveled all the way from Payerne, Switzerland, to participate in The Magnificent Mile Lights Festival in 2002. Festive music and colorful costumes are the hallmark of this band, a participant of Lucerne, Switzerland's Carnival. Camille Julmy of U.S. Equities and the former chairman of The Greater North Michigan Avenue Association was the catalyst in bringing the band to Chicago for this event. (Courtesy of Stanley Wlodkowski.)

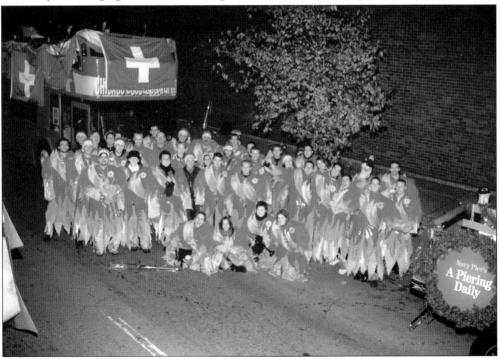

Walt Disney World Resort's 100 Years of Magic celebration returned in 2002, featuring the new addition of characters Lilo and Stitch. Stitch joined Mickey Mouse for a media event in advance of the festivities where he revealed his mischievous side while helping Mickey test the lights. (Courtesy of Stanley Wlodkowski; Disney characters © Disney Enterprises, Inc. Used by permission from Disney Enterprises, Inc.)

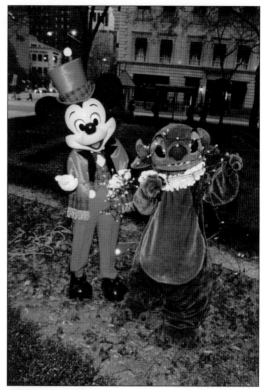

The Navy Pier Players, Navy Pier's a capella singing troupe featuring Julie Garland, Clara Bow, Treat Williams, Rudy the Reindeer Wrangler, Sir Snowsalot, Rag Dolly Holly, Carol Claus, Hans Tinker Toy Maker, and General Merriment the Toy Soldier, entertained during the day's events and evening procession. (Courtesy of Stanley Wlodkowski.)

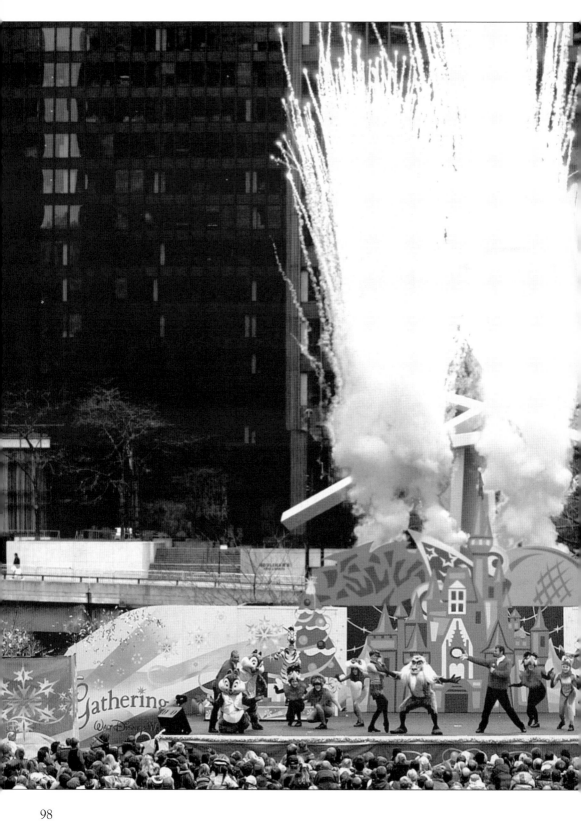

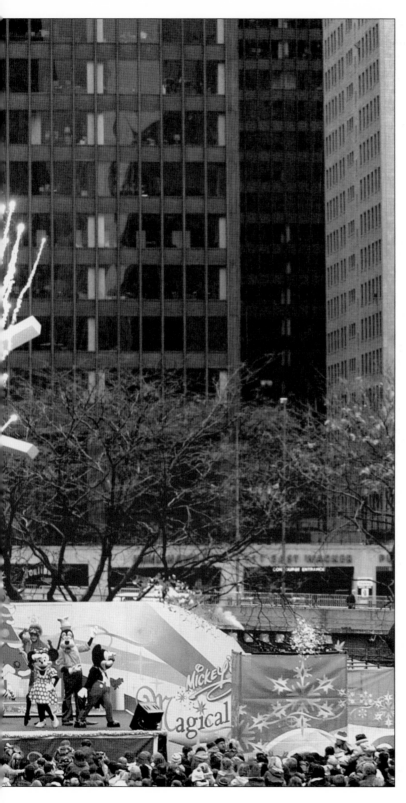

A roster of Disney characters enjoyed a grand finale complete with pyrotechnics during the new stage show for The Magnificent Mile Lights Festival in 2003, which celebrated Magical Gatherings. Disney's live shows, held in Pioneer Court with the Chicago River as a backdrop, drew as many as 10,000 viewers per show. (Courtesy of the Chicago Tribune; Disney characters © Disney Enterprises, Inc. Used by permission from Disney Enterprises, Inc.)

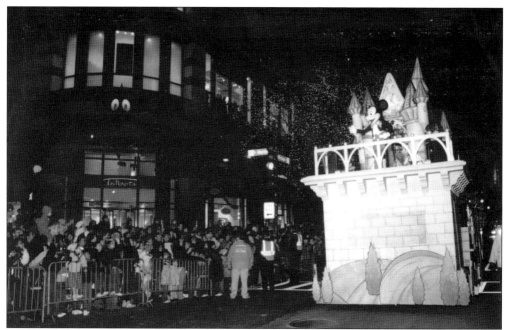

Master of ceremonies, Mickey Mouse, standing in the forecourt of Cinderella Castle, rode on this new float created especially for the festival in 2003, lighting up The Magnificent Mile block by block. (Courtesy of Stanley Wlodkowski; Disney characters © Disney Enterprises, Inc. Used by permission from Disney Enterprises, Inc.)

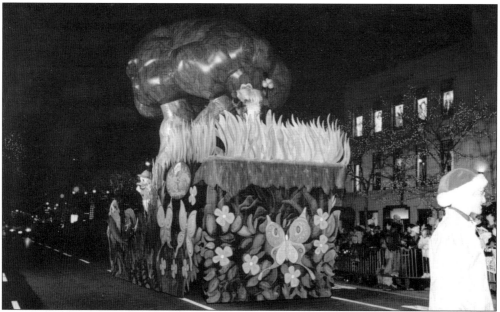

Rafiki and Safari Donald had a wild time traveling down The Magnificent Mile aboard a majestic Tree of Life vehicle from Disney's Animal Kingdom Park. Both vehicles, constructed by Disney producers, were almost 20 feet tall, brightly illuminated, and played festive music. (Courtesy of Stanley Wlodkowski; Disney characters © Disney Enterprises, Inc. Used by permission from Disney Enterprises, Inc.)

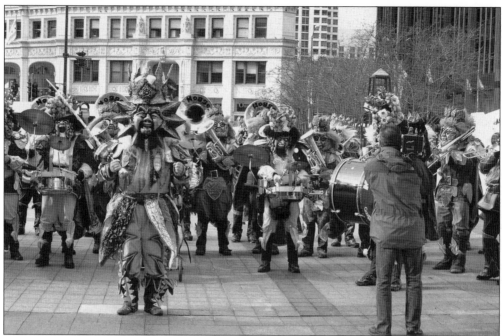

The Chicago-Lucerne Sister Cities Committee welcomed Noggeler Guuggenmusig from Switzerland to The Magnificent Mile Lights Festival in 2003, courtesy of Presence Switzerland, the Swiss Club of Chicago, and the Consulate General of Switzerland in Chicago. This band wore fanciful costumes that were fabricated by its members. They performed early in the day in Pioneer Court and were a feature of the lighting procession. Lucerne is a one of 26 sister cities to Chicago. Others include Paris, Moscow, Shanghai, and Toronto. The Magnificent Mile has many partnerships in place with cities around the world that feature great avenues. (Courtesy of Stanley Wlodkowski and John Maxson.)

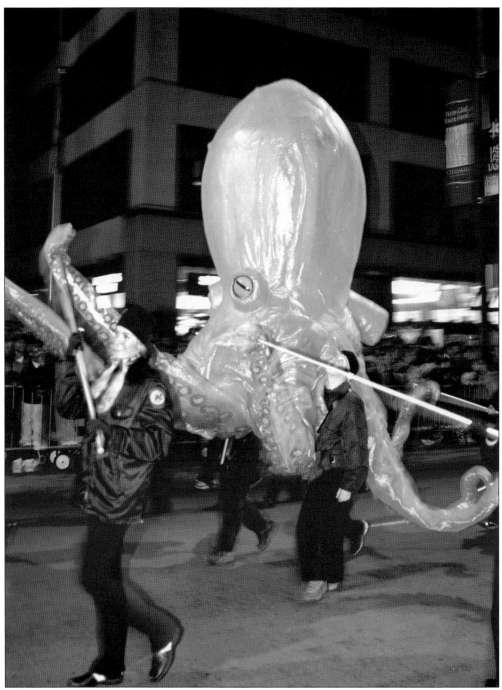

Shedd Aquarium created spectacular puppets for The Magnificent Mile Lights Festival to celebrate the opening of Wild Reef, a new 750,000-gallon exhibit housing coral polyps, sharks, rays, sea horses, and colorful reef fish. A shark, blue-spot stingray, and an octopus swam down the procession route in front of 900,000 viewers. Shedd puppets in future years of The Magnificent Mile Lights Festival included a brightly colored crab and spectacular Beluga whale puppets. (Courtesy of Stanley Wlodkowski.)

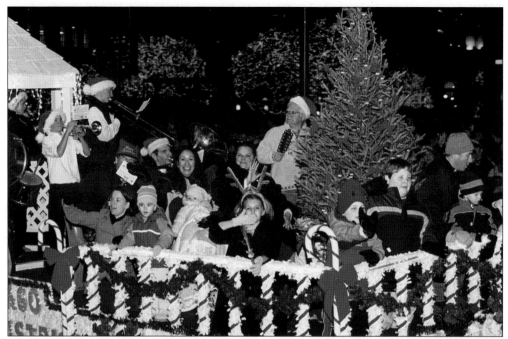

An annual participant in The Magnificent Mile Lights Festival, the Chicago Park District presented a vehicle titled Holiday Delights, which displayed what Chicagoans might expect to find at their local park districts each holiday season. (Courtesy of Stanley Wlodkowski.)

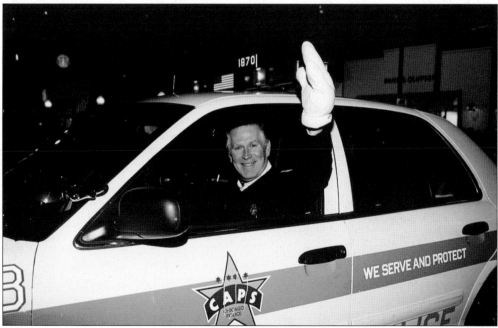

Hundreds of Chicago police and other city employees play critical roles in the success of The Magnificent Mile Lights Festival. Sgt. Keith Mayo, who has provided service to residents and businesses along The Magnificent Mile for more than 12 years, shows his enthusiasm for the celebration. (Courtesy of Stanley Wlodkowski.)

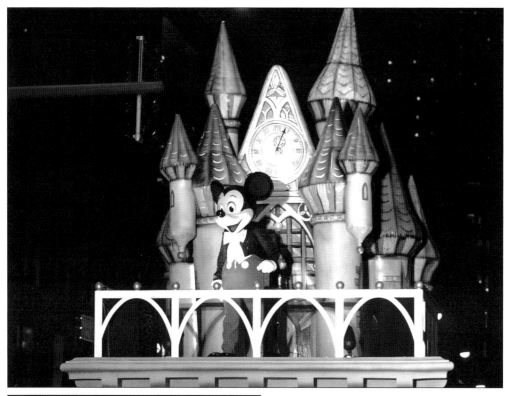

Mickey Mouse returned to The Magnificent Mile with Cinderella Castle as the lead vehicle in 2004. Stitch rode on the back courtyard of the Castle, amusing the crowds with his antics. (Courtesy of Stanley Wlodkowski; Disney characters © Disney Enterprises, Inc. Used by permission from Disney Enterprises, Inc.)

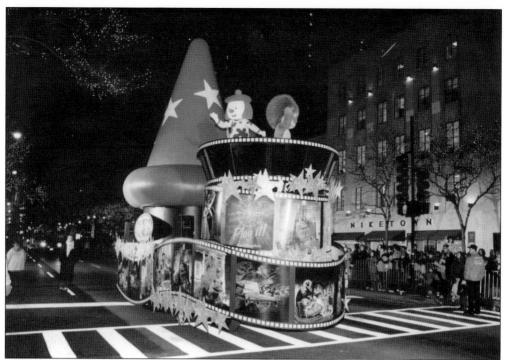

Mickey also brought along JoJo and Goliath, headliners of preschool favorite *JoJo's Circus*, airing on the Disney Channel, who rode the Disney-MGM Studios float. Cruella de Vil, the villain from Walt Disney's 1961 animated feature *One Hundred and One Dalmatians*, and Maleficent, the self-proclaimed "mistress of all evil" from Walt Disney's 1959 animated feature *Sleeping Beauty*, were banished to the back of the vehicle, as well as favorite friends, Space Goofy, Snow White, Cinderella, and Belle and the Beast to the 2004 festival. (Courtesy of Stanley Wlodkowski; Disney characters © Disney Enterprises, Inc. Used by permission from Disney Enterprises, Inc.)

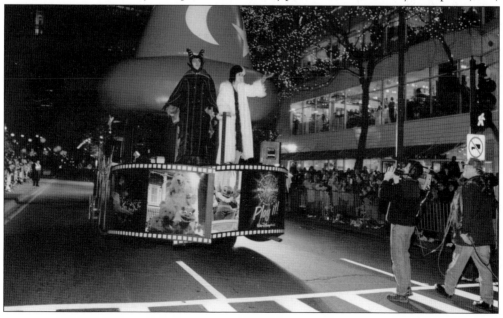

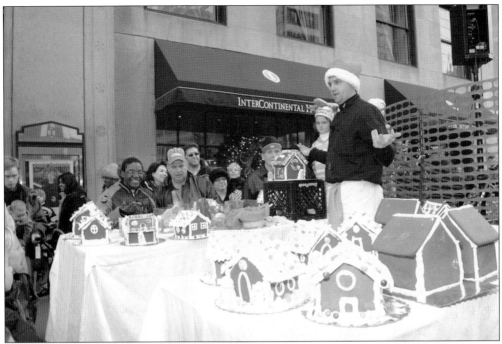

In 2005, InterContinental Chicago offered gingerbread-house assembly and decor seminars in addition to its annual live ice-carving demonstrations. (Courtesy of Stanley Wlodkowski.)

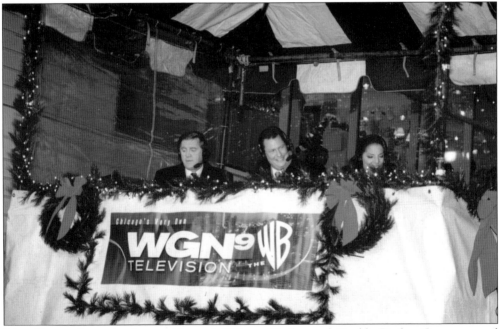

John Curran (center), vice president of Chicago Trolley and Double Decker Company and chairman of the 2004 and 2005 events, provided color commentary about the 2004 procession for the Emmy-nominated live broadcast of The Magnificent Mile Lights Festival. He is pictured alongside Allison Payne and Steve Sanders, evening anchor talent for the station. (Courtesy of Stanley Wlodkowski.)

A talented team of Disney producers, including, from left to right, Kelly Benton, Steve Secor, Jack Gooch, and Chris Ort, travel from Walt Disney World Resort in Florida each year to assist with the production of The Magnificent Mile Lights Festival. (Courtesy of Stanley Wlodkowski.)

Delightful duo Chicken Little and Abby Mallard made an appearance to celebrate the 2005 release of the new *Chicken Little* movie, riding atop the Disney-MGM Studios vehicle. (Courtesy of Stanley Wlodkowski; Disney characters © Disney Enterprises, Inc. Used by permission from Disney Enterprises, Inc.)

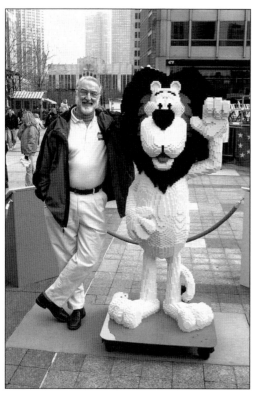

In 2006, the official name of The Magnificent Mile Lights Festival was changed to The Magnificent Mile Lights Festival presented by Harris. Harris, an institution in Chicago for 125 years, committed substantial financial and volunteer support of The Magnificent Mile Lights Festival, enabling the event to grow to national proportions. Harris employees participated on the planning committee, and Harris recruited hundreds of volunteers from its employee base. Harris commissioned Lego experts to build Hubert the LEGO Lion to celebrate its sponsorship, who after his debut at The Magnificent Mile Lights Festival, traveled to Harris branches in the Midwest. The real Hubert, a costumed character, made an appearance during the lighting procession. (Left, courtesy of John Maxson; below, courtesy of Stanley Wlodkowski.)

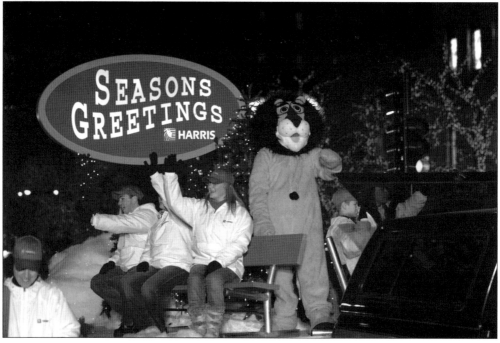

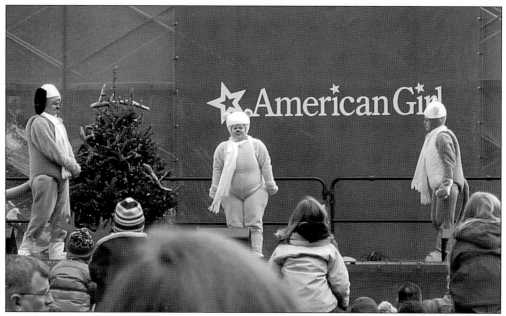

A wide variety of stage performances were the new highlights of the daytime entertainment on the Harris stage in Pioneer Court in 2006. The Harris Choir opened the day with holiday tunes, and girls in attendance were thrilled to see the American Girl Ambassadors and Bitty Babies come to life on an outdoor stage in a production by American Girl Theater. (Courtesy of The Greater North Michigan Avenue Association.)

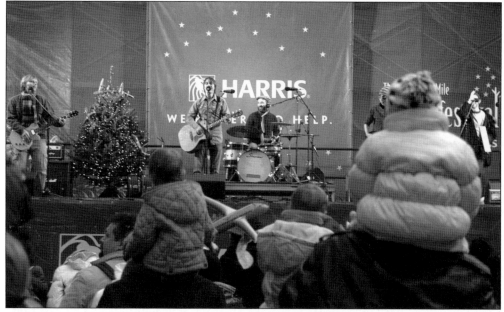

Justin Roberts and the Not Ready for Naptime Players closed the variety show as the crowd prepared for Mickey's arrival and the lighting of Michigan Avenue. A native Chicagoan who performs children's concerts around the country, Roberts was a new addition to the festival in 2006. Families jumped, sang, and danced as the night sky darkened. (Courtesy of Davis Harrison Dion.)

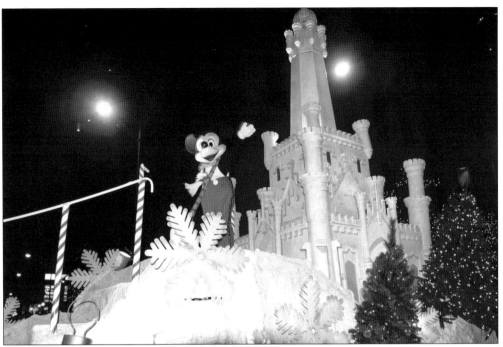

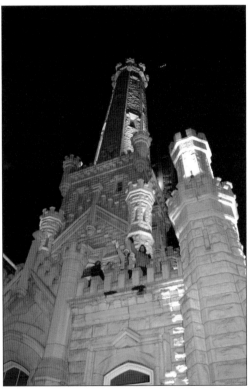

Mickey enjoyed a new ride in 2006. This new, custom-created lead vehicle was modeled after North Michigan Avenue's historic icon, the Water Tower. Exceptional care was taken in the construction of the vehicle, which took three months, before it was packed on a truck and transported to the start of the procession route for final assembly. As the vehicle passed the Water Tower for the first time on the eve of its debut, its realism was striking, even to those viewing the procession from the actual Water Tower. (Courtesy of Stanley Wlodkowski; Disney characters © Disney Enterprises, Inc. Used by permission from Disney Enterprises, Inc.)

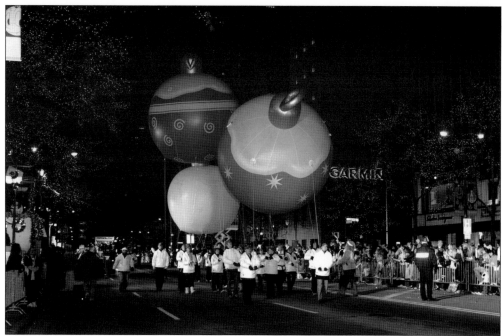

Custom balloons specifically created to travel down The Magnificent Mile were another first for the 2006 event, a stellar year of entertainment. More than 18 feet in diameter, these fanciful, interior-lit ornament and giant snowflake balloons took six weeks to build and required 34 handlers, all volunteers from area businesses, including Harris, *Chicago* magazine, and several hotels. The volunteers trained for the event at a balloon school. The weather held on the day of the event with only light winds, enabling the balloons to travel down North Michigan Avenue to the crowd's delight. (Courtesy of Stanley Wlodkowski.)

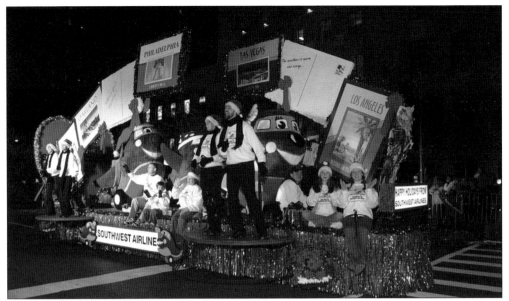

The Southwest Airlines vehicle showcased the Chicago Human Rhythm Project, an organization that promotes American tap dance, in 2006. The high-energy vehicle featured six dancers tapping on specially made platforms. Southwest Airlines, a dedicated supporter of the event, gathered thousands of warm items to hang on its mitten tree, an annual feature of The Magnificent Mile Lights Festival benefiting families served by the Salvation Army. Southwest Airlines has been a sponsor of The Magnificent Mile Lights Festival since 1996. (Courtesy of Stanley Wlodkowski.)

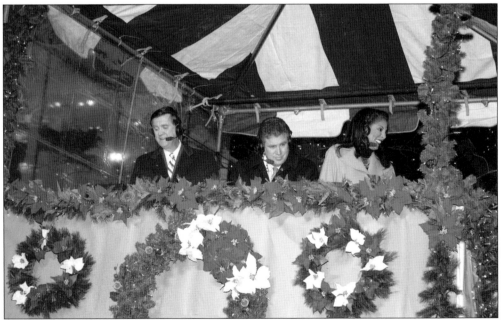

Marc Schulman (center), founding chairman of The Magnificent Mile Lights Festival, joined WGN-TV Channel 9 personalities Steve Sanders and Alison Payne in the broadcast booth to talk about the 2006 festival. (Courtesy of Stanley Wlodkowski.)

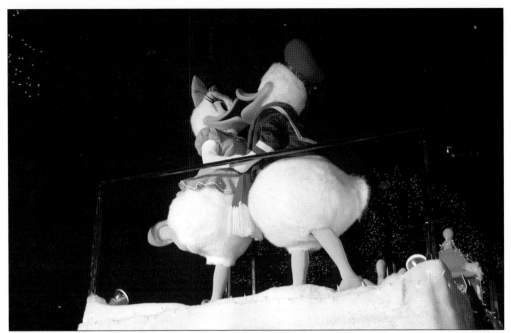

Donald and Daisy Duck, riding aboard the clock-tower vehicle, stole a kiss as they followed Mickey down the procession route, swept up in, as many couples are, the romance of North Michigan Avenue during the holiday season. (Courtesy of Stanley Wlodkowski; Disney characters © Disney Enterprises, Inc. Used by permission from Disney Enterprises, Inc.)

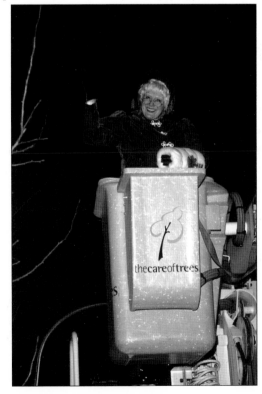

Honoring North Michigan Avenue's long tradition of beautification, Mrs. Claus traveled down The Magnificent Mile in the bucket of a Care of Trees vehicle, which was used to prune and inspect trees as well as string the holiday lighting. The trees in The Magnificent Mile district have longer life spans than those in other urban destinations because of the quality of care provided by area property owners. (Courtesy of Stanley Wlodkowski.)

New advertising was created in 2006 by advertising agency and Greater North Michigan Avenue Association member Davis Harrison Dion, promoting the unique attributes of The Magnificent Mile Lights Festival. (Courtesy of Davis Harrison Dion; © Disney Enterprises, Inc.)

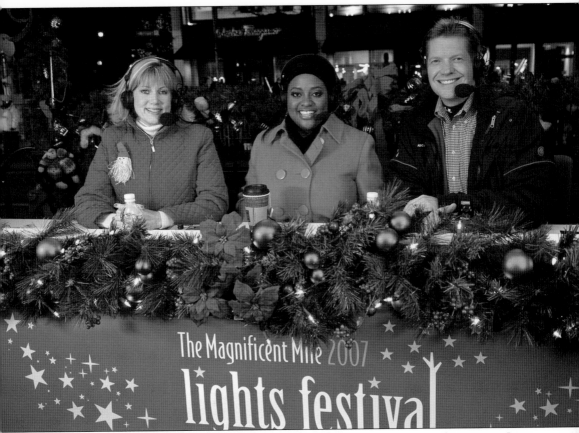

ABC 7 Chicago broadcast The Magnificent Mile Lights Festival across the nation. Janet Davies (left), Alan Krashevsky, and Sherri Shepherd from *The View* introduced each procession vehicle to the viewing audience. The station syndicated the live televised broadcast across North America in 2007, granting access to Chicago's kick off to the holiday season to millions more viewers. The lights festival broadcast was the first holiday event presented in high definition for the station. (Courtesy of ABC 7 Chicago.)

In 2007, nationally known children's singer and songwriter Justin Roberts and his Not Ready for Naptime Players performed for ecstatic children early in the day and also appeared on a candy and ice-cream laden procession vehicle. The recipient of four parents choice gold awards for his albums, Roberts has performed for the *Today Show*'s Summer Concert Series and began his career writing and performing songs for his Montessori preschool students. (Courtesy of Davis Harrison Dion.)

Ralph Covert of Chicago's Bad Examples fame boogied down the procession route with his kids-music band Ralph's World after a rousing daytime performance. The Disney sound recording star received a Grammy nomination for *Green Gorilla, Monster and Me*. (Courtesy of Davis Harrison Dion.)

Grammy-nominated KT Tunstall stopped by the Harris stage to entertain crowds. Tunstall's musical blend of rock, pop, alternative, and acoustic has risen in the charts worldwide and was popular with the crowds in attendance. (Courtesy of Davis Harrison Dion.)

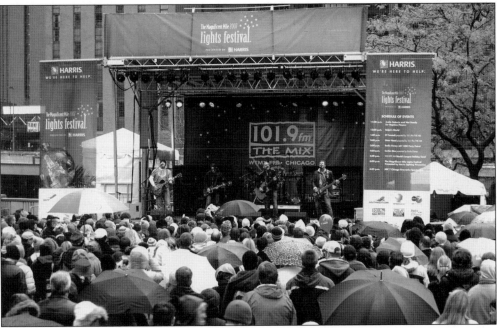

Sister Hazel's platinum-selling music filled Pioneer Court as they performed songs from their holiday release, *Santa's Playlist*. Later, the popular group was aboard the 101.9 FM The Mix holiday float featuring *The Eric and Kathy Show*. Eric Ferguson, Kathy Hart, Melissa McGurren, John Swanson, and Cynthia Skolak waved to fans. (Courtesy of Davis Harrison Dion.)

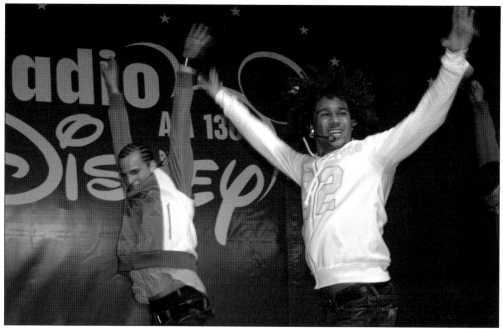

Corbin Bleu presented by Radio Disney was the final performance on the Harris stage for the November 18, 2006, event. Screaming fans held handmade signs high in the air as Bleu performed songs from his recently released first solo album on Hollywood Records titled *Another Side*. Corbin is known for his role as Chad Danforth in the Disney Channel original movies *High School Musical* and *High School Musical 2*. (Courtesy of Stanley Wlodkowski; Used by permission from Disney Enterprises, Inc.)

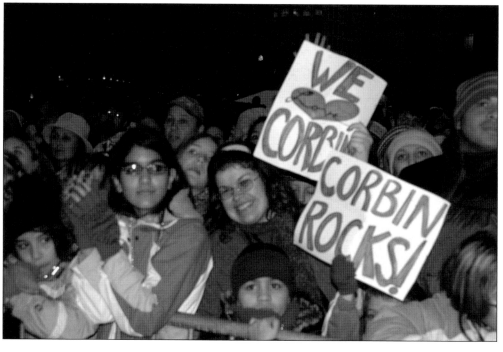

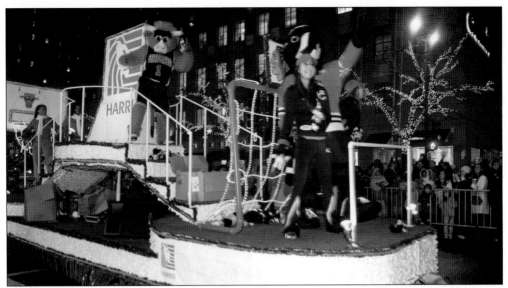

As part of its 125th corporate anniversary, Harris highlighted its role in helping communities grow and prosper. The Harris float featured several of the organizations the company supports, including the United Way and Toys for Tots. Harris also brought Benny the Bull, the mascot for the Chicago Bulls, and Tommy Hawk, the mascot for the Chicago Blackhawks, to The Magnificent Mile Lights Festival in 2007 to promote its sponsorship of these two Chicago sports teams and the Bulls's Adopt-A-School program, which encourages students to excel in their studies. (Courtesy of Stanley Wlodkowski.)

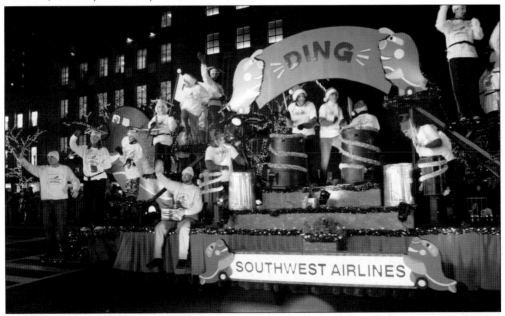

Be the Groove drum line, a Chicago-based rhythmic performance ensemble fusing movement, percussion, and rhythm, was the featured entertainment on the Southwest Airlines vehicle in 2007, creating rhythmic, rocking sounds as the float made its way down North Michigan Avenue. Each year, the airline brings enthusiasm and heart to the event. (Courtesy of Stanley Wlodkowski.)

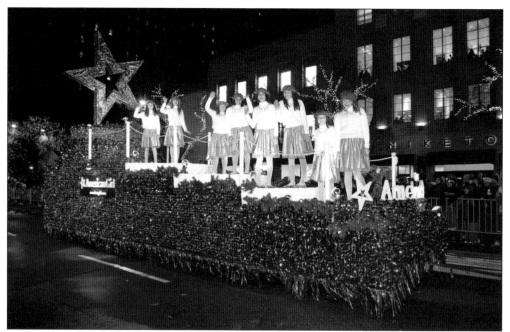

A spectacular float designed by American Girl Place, one of Chicago's top tourist destinations for girls and their families, featured singing and dancing from the American Girl Ambassadors, a performance group selected from the cast of young performers at the American Girl Theater. Located in the heart of Chicago's Michigan Avenue shopping district, American Girl Place Chicago features products for girls ages three and up, as well as a café, a doll hair salon, photograph studio, and a 150-seat theater. (Courtesy of Stanley Wlodkowski.)

In 2007, Chicago's Museum of Science and Industry float highlighted some of the festive sights on display at its 66th annual Christmas Around the World and Holidays of Light display. The exhibit features a forest of more than 50 dazzling trees decorated by volunteers from Chicago's ethnic communities to reflect holiday traditions from around the world, including Hanukkah, Diwali, and Kwanzaa. (Courtesy of Stanley Wlodkowski.)

The University of Illinois at Chicago pep band and its cheerleaders showed their spirit at The Magnificent Mile Lights Festival in 2007. This university is the largest public university in the Chicago area, serving more than 25,000 students and offering a range of studies, including business, architecture, the fine arts, liberal arts, and health care. (Courtesy of Stanley Wlodkowski.)

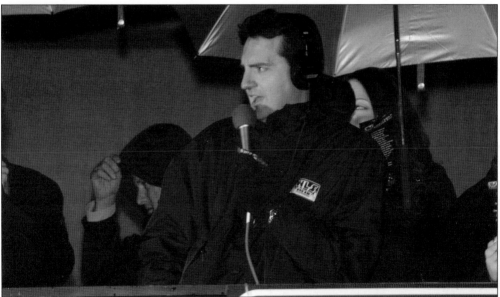

As the crowd gathered for the lighting procession, Chicago's Talk Station, WLS 890 AM, organized those along the parade route into a record-breaking attempt for the world's largest holiday carol. The radio station led more than 15,000 singers through three songs, thereby breaking the previous world record of 7,500 singers caroling. Later, the station's on-air personalities, including Don and Roma Wade, Jerry Agar, and Roe Conn waved from a procession vehicle. (Courtesy of WLS 890 AM.)

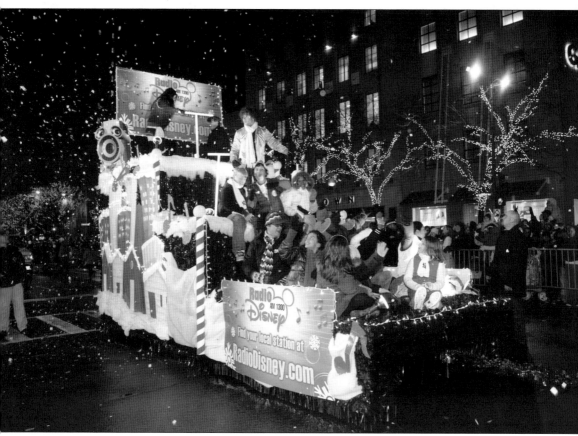

Corbin Bleu rode atop the Radio Disney procession vehicle along with Radio Disney AM 1300 disc jockey talent. Snow from Santa's sleigh, the final vehicle of the 2007 procession, fell softly as Bleu performed "It's Christmastime" from the Walt Disney Records' *Disney Channel Holiday* CD. The combination of the two vehicles made for a magnificent end to a magical night. (Courtesy of Stanley Wlodkowski; Disney characters © Disney Enterprises, Inc. Used by permission from Disney Enterprises, Inc.)

The final vehicle in The Magnificent Mile Lights Festival is the one everyone waits for—the arrival of Santa Claus, who officially ushers in the season. In 2006, Santa arrived on the sleigh vehicle made for the 1994 movie version of *Miracle on 34th Street*. Now an exclusive part of North Michigan Avenue's festival, the vehicle features thousands of tiny white lights, mirroring the trees, as Santa steers his sleigh full of holiday gifts for good girls and boys over rooftops. Surprise snow blasts from the vehicle on each block created swirling drifts and cheers from on-lookers, resulting in an exciting transition to the 2006 procession's grand finale—the fireworks. (Courtesy of Stanley Wlodkowski.)

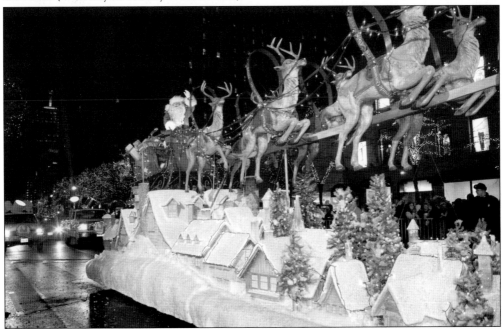

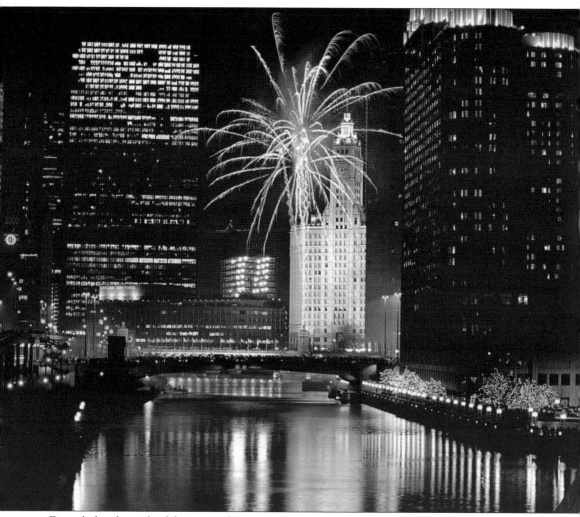

Every lights festival celebration culminates in a spectacular fireworks display at the gateway to The Magnificent Mile at Michigan Avenue and the Chicago River. Lumina Fireworks is the exclusive provider for the event and annually uses more than 10,000 handmade fireworks shells for these displays. (Courtesy of the Chicago Tribune.)

Some of the unsung heroes of this annual holiday event are the building engineers who man their posts inside each property lining The Magnificent Mile during the festival. Ready for their cue, they stand poised to flip the switches in sync and illuminate the trees from rooftops, basements, and other remote locations. Some engineers, pictured here with lights festival leadership, have been turning on the lights for their property since the event's inception in 1992. (Courtesy of The Greater North Michigan Avenue Association.)

More than 400 volunteers plan for 10 months to produce The Magnificent Mile Lights Festival. Some 800 volunteers, including district ambassadors and hotel concierges, assist in the day-of execution of the event. (Courtesy of Davis Harrison Dion.)

A dedicated operations crew arrives early in the morning before each Magnificent Mile Lights Festival to ensure the event is ready for its guests.

The Legacy of Leaders is an esteemed group of volunteer chairpersons from The Greater North Michigan Avenue Association. Each of these individuals act as a steward of The Magnificent Mile's legacy of world-class holiday celebrations by leading the all-volunteer planning committee of the lights festival for a two-year term each. Volunteer chair people of The Magnificent Mile Lights Festival include Marc Schulman, 1992–1995; Heinz Kern, 1994–1995; Steve Pliska, 1996; Grant DePorter, 1996–1999; Kelly Wisecarver, 2000–2001; Greg Horeth, 2002; John Chikow, 2002–2003; John Curran, 2004–2005; David Froelke, 2004; Nicole Jachimiak, 2006–2007; Jennifer Woolford, 2008; Bob Dion, 2008; and Eric Kromelow, 2008.

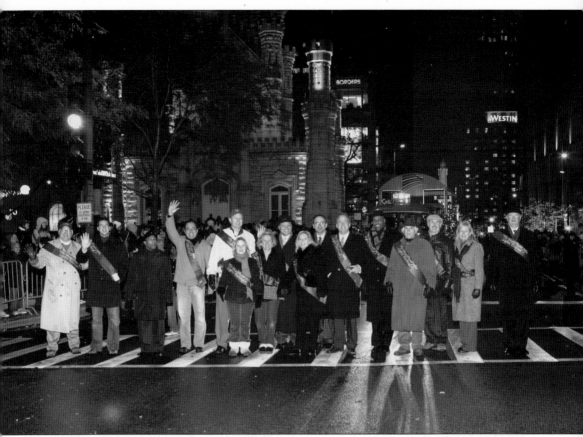

North Michigan Avenue is a street deserving of its reputation for magnificence. For more than 100 years, the leaders, residents, business owners, and volunteers have actively guided the infrastructure, activities, and heart and soul of North Michigan Avenue and its surrounding neighborhoods. From Daniel Burnham's plan to the development of the pioneering Michigan Avenue bridge to the last vehicle of the last Magnificent Mile Lights Festival, a dedicated community of visionaries have been at the helm, ensuring The Magnificent Mile's future as one of the great avenues of the world. As always, North Michigan Avenue's strength lies in the hearts of its visionaries and its volunteers. John Chikow, a volunteer chairman of The Magnificent Mile Lights Festival from 2002 to 2003, noted, "The scope and breadth of the Lights Festival—and The Magnificent Mile community—is matched only by the heart demonstrated by the hardworking members of The Greater North Michigan Avenue Association, and its sponsors and city partners. To see this event become a family tradition for so many thrills those of us who work on it. The delighted smiles on the faces of our guests when the lights go on are etched in the memories of all of us who play a role in the production of this event." The Magnificent Mile is one of the great adventures of the world and a perfect stage for extraordinary holiday festivities for many years to come.

ACROSS AMERICA, PEOPLE ARE DISCOVERING
SOMETHING WONDERFUL. THEIR HERITAGE.

Arcadia Publishing is the leading local history publisher in the United States. With more than 3,000 titles in print and hundreds of new titles released every year, Arcadia has extensive specialized experience chronicling the history of communities and celebrating America's hidden stories, bringing to life the people, places, and events from the past. To discover the history of other communities across the nation, please visit:

www.arcadiapublishing.com

Customized search tools allow you to find regional history books about the town where you grew up, the cities where your friends and family live, the town where your parents met, or even that retirement spot you've been dreaming about.